To My Sister &

IMAGES
of America
NORWOOD

A trip down memory lane.

Love,

Carol

On the cover: These young boys play during recreation time at the Norwood Service League's house. The Norwood Service League (NSL) originated in April 1917 as a response to those affected by World War I. Many married men had been called into active duty, and the wives were left to get jobs of their own. Many women struggled to raise their children and provide for their families. In response to these concerns, the league was originally created to support the Red Cross in its war efforts and has since expanded its welfare mission. Local churches, lodges, clubs, and industries continue to support the NSL.

Christine Mersch

Happy Norwood memories,

Copyright © 2006 by Christine Mersch
ISBN 0-7385-4038-2

Published by Arcadia Publishing
Charleston SC, Chicago IL, Portsmouth NH, San Francisco CA

Printed in the United States of America

Library of Congress Catalog Card Number: 2006922315

For all general information contact Arcadia Publishing at:
Telephone 843-853-2070
Fax 843-853-0044
E-mail sales@arcadiapublishing.com
For customer service and orders:
Toll-Free 1-888-313-2665

Visit us on the Internet at http://www.arcadiapublishing.com

This book is dedicated to the people of Norwood.

CONTENTS

Acknowledgments 6

Introduction 7

1. In the Classroom 9

2. Sources of Spirituality 21

3. Giving Back 33

4. Neighborhood Events 53

5. Daily Jobs 63

6. Notable Sights 105

ACKNOWLEDGMENTS

The Norwood Historical Society has been extremely wonderful in helping with the research of this book, and to them I am thankful. I would especially like to thank Venice Brown, Rodney Rogers, Bob Hilvers, and Mark Lewis for their willingness to discuss local history. Special thanks goes to other historians in the community, including Kim Malloy at the Norwood branch of the Cincinnati Public Library, Lupe Hoyt at the Norwood Service League, Maj. Larry See at the Salvation Army, Linda Brim, Dolly Lyons of the Zumbiel company and Norwood Business Association, Capt. Keith Belleman with the Norwood police, Capt. Chuck Fischer with the Norwood fire department, Sue Rosebraugh of the Our Lady of the Holy Spirit Center (OLHSC), Harriet "Hap" Arnold of the Norwood Enterprise and Historical Society, Steve Thornbury, Betty Smiddy, Joani Policastro, and Ruth Austing.

I would also like to thank the many other Norwood residents, friends, and historians who have come before me and made great contributions to Norwood's history, including Francis Hannaford, Mildred Schulze, Margaret Guentert, Lillian and Allen Roudebush, Ren Mulford, and Werter G. Betty.

Finally, I would like to thank everyone who personally supported me in this endeavor and everyone who bought my first book. May you feel generous once again.

INTRODUCTION

One of the first buildings in Norwood was Samuel D. Bowman's tavern for travelers, built in 1809 between Montgomery and Smith Roads. John Sharp, who may have owned a store nearby, joined Bowman to form the settlement, which was originally called Sharpsburg. In 1869, Sharpsburg officially became Norwood by a vote of popular consent. Some say the name was inspired by Henry Ward Beecher's novel titled *Norwood: Or, Village Life in New England*. Others think it is a combination of "North Woods," the name given to the view from the property of early settlers L. Bolles and his wife, Sarah.

The area became an incorporated village on May 14, 1888. In the first municipal election on August 6 of that same year, 199 votes were cast. The village grew at a rapid rate. For the 1892 presidential vote, 1,026 Norwood citizens went on record to cast their votes. By 1894, almost 70 passenger trains passed through the area per day.

In 1902, council members suggested making Norwood a city and residents agreed. On May 4, 1903, the village officially became a city when Mayor George E. Wills issued the proclamation. The city continued to grow throughout the early 20th century, from 33,000 residents in the 1930s to its peak population of 35,000 residents in the 1950s (according to the U.S. Census Bureau). The city suffered a financial downfall in 1986 when General Motors announced it was closing. This caused a loss of approximately 4,000 jobs and was an economic strain on the city. Now, in the year 2006, Norwood is holding steady with a population greater than 21,000. The following chapters will give the reader a peek into the past of this active community.

Chapter 1, titled "In the Classroom," tells the history of the Norwood public school district, including Sharpsburg Elementary School, Allison Street Elementary School, and other Norwood schools, through images. Chapter 2, "Sources of Spirituality," highlights religious schools, churches, and seminaries that have guided religious Norwoodites for years. These churches reflected the city's diversified faith and included Baptist, Catholic, Methodist, Jewish, Christian Scientist, Lutheran, and Presbyterian congregations.

In chapter 3, "Giving Back," readers will get a glimpse of the many organizations that were founded to help Norwood citizens and the people who worked hard to help their neighbors. Both the police and fire department histories are highlighted in this chapter, as well as the Norwood Service League.

"Neighborhood Events," chapter 4, focuses on events that Norwood natives remember attending, or remember their parents and grandparents talking about. Two special events included are Norwood Day and the Norwood Day parade, both of which celebrate the strong community spirit of Norwood. Other pictures included in this section are of the many social clubs that called Norwood home. These include the Cary Literary Club and the Cine Club.

The first factory in the area, built in 1897 or 1898, belonged to the Bullock Electric Company, which is now a part of Siemens AG—a worldwide electronics company. This business and others, past and present, are showcased in chapter 5, "Daily Jobs."

Finally, in chapter 6, we will look at all the special sights in Norwood. "Notable Sights" includes houses, parks, and street scenes that have been staples in the area. Norwood is alive with history, if one simply takes a step back to observe. This book brings to light the stories and photographs that have made this city great. It is especially relevant now, as those who live in and around Norwood watch with great wonder at all the change that is happening in the area. With this book, you can take a step back into time and learn how life used to be. Enjoy.

—Christine Mersch

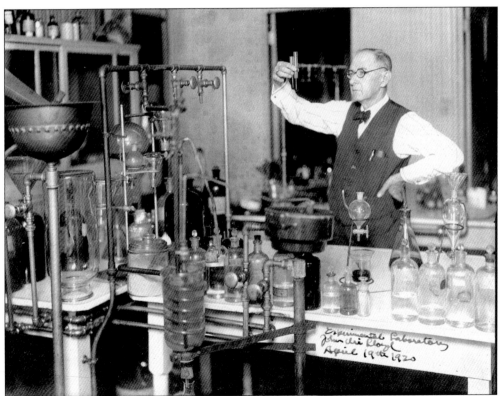

This picture of John Uri Lloyd was taken on April 19, 1920, as he worked in his experimental laboratory. Lloyd was well known for his unusual brand of Eclectic Pharmacy, as well as his literary works. Lloyd published many novels as well as scientific studies, including *Etidorhpa* in 1895 and a series of six *Stringtown* novels about his childhood in Kentucky. Lloyd worked in downtown Cincinnati, but he called Norwood home in his later years.

One

IN THE CLASSROOM

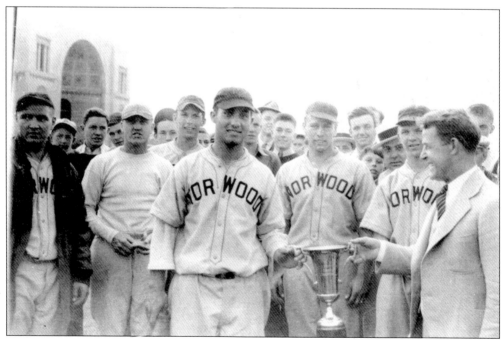

This 1936 picture shows the trophy presentation of the baseball state championship to members of the Norwood High School baseball team. In the front row stands, from left to right, Andy Rahe, George Winkelman, Erv Pangallo. Pangallo is accepting the trophy from coach "Dutch" Ludwig. Behind them stands Tower Robertson and George Freiberger. In 1929, the baseball team won both the district and regional championships and went as far as the semifinals at the state tournament. In 1958 and 1968, the team won the H.C.L. and H.C.S.L. Championships, respectively.

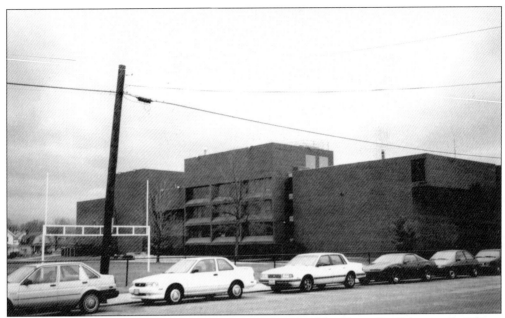

This picture shows the present-day Norwood High School building. On February 3, 1970, a public school bond was passed by Norwood residents to build a newer high school building adjacent to the original school structure. Construction started in July 1970, and the school opened for upper grades in May 1972. An indoor bridge connects this building with the old structure (now designated for middle school students).

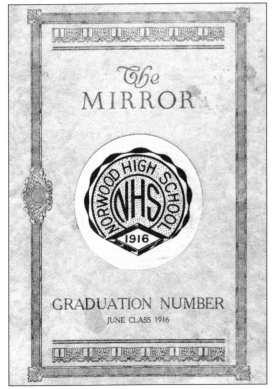

This is a picture of the 1916 Norwood High School yearbook, *The Mirror*. The 1916 Norwood football team won the Champions of Southern Ohio title, and the 1921 team won the Championship of the City of Cincinnati. One of the nearby parochial schools in the area was St. Elizabeth, which opened in 1887 with 44 students. Teachers came from the Sisters of Charity, based at Mount St. Joseph.

This picture shows Edward B. Kinsel when he was 18 years old. Kinsel was a four-year football player at the Norwood High School, earning three reserve letters and one varsity letter. In the 1949–1950 season, Kinsel was elected cocaptain. His coach at this time was Dave Query. Norwood High School started its program in 1907. That year, the team had four wins, two losses, and just one tie. The first coach was August Eckel, who worked as the physical training director for all Norwood schools. The Norwood football team has a long record of winning. In 1910, for instance, the football team was undefeated. In 1911, they scored 106 points versus 21 points scored by their opponents, and the next year's team scored 180 points versus 0 points during regular season play. Another interesting fact is that each player on the 1915 football team weighed an average of 135 pounds. They still won the title of Cincinnati Champions.

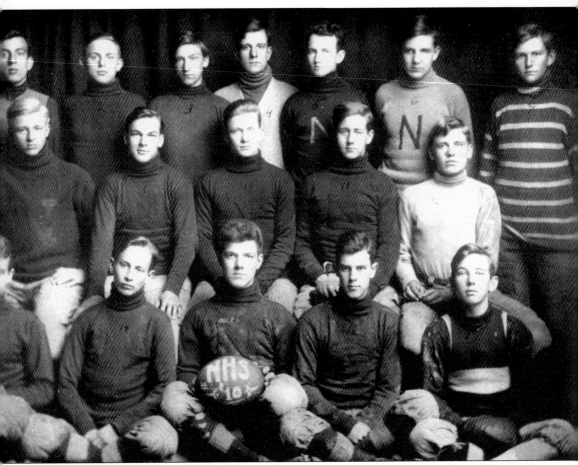

This is a picture of a 1910 Norwood High School football team. From left to right are (front row) Wiedmer (left tackle), A. Wilson (quarterback), L. Baehr (fullback and captain), S. Evans (right end), and W. Kochman (guard); (second row) F. Werner (center), J. Grisard (left halfback), C. Loundsberry (right guard), N. Wirthlin (left halfback), and F. Sorensen (left tackle); (third row) C. Gunter (right halfback), E. Neider (quarterback), Bud Meyers (position of footballer), S. Betz (guard), H. Hewitt (left end), and H. Smith (left tackle), and unidentified. Some of the teams they won against are Lawrenceburg, Franklin, Erlanger, Woodward, Hughes, and Covington. Grover Schulte played center on the 1912–1913 team and remembers playing games in the Norwood ballpark. Players would bring all their equipment to school on the day of the game and change into their uniforms after school, under the bleachers. Schulte says each player contributed their own money to buy equipment, and jerseys from last year's team were still used during the season he played. The uniform was a blue jersey with a red *N* on the front.

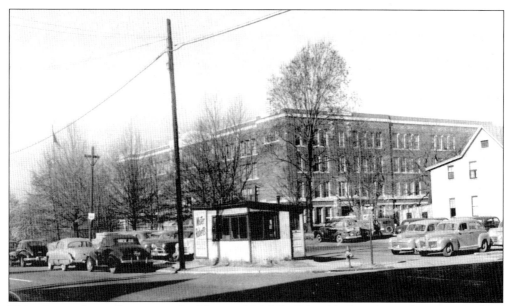

This picture shows the present-day Norwood Middle School before the parking lot was built next door. Norwood schooling was restricted to lower-grade course work until 1885, with the introduction of grade level D, the equivalent of one year in high school. Payment for nonresidents was $20 for a full year of classes. In 1895, Norwood established its high school program and initiated a four-year plan. The curriculum included classes in English, reading, composition, rhetoric, Latin, French, algebra, and chemistry.

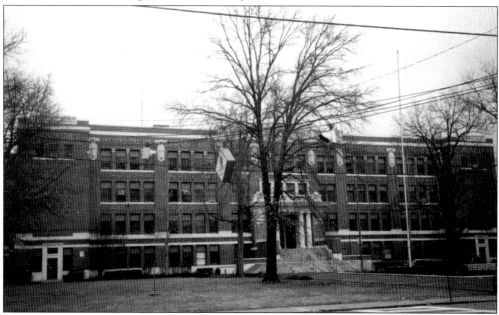

This picture shows the present-day Norwood Middle School. The first Norwood school bond was passed in 1884 by a vote of 32 to 1 for an amount of $8,000. In 1979, the building was the Norwood Junior High, and in 1988, the building was designated as the Norwood Middle School. The sidewalk can be seen in the center of the shot. The first sidewalk was built in Norwood in 1875 on the east side of Montgomery Road between Mound and Sherman Avenues.

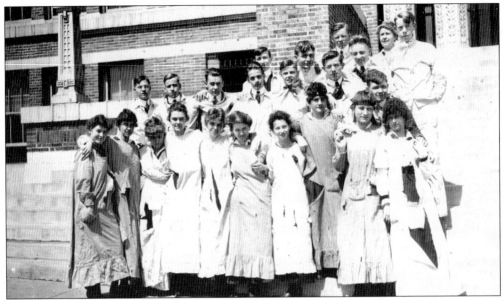

This picture was taken outside the present-day Norwood Middle School. In 1903, the kindergarten levels were introduced, and home economics classes were started in 1914. In 1921, French and Latin languages were made optional. In 1972, the building was used specifically for junior high school students, due to overcrowding. Colleges in the Norwood area include Xavier University and ITT Technical Institute.

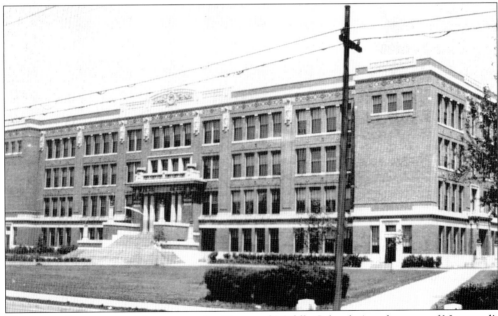

This is another picture of the present-day Norwood Middle School. Another one of Norwood's early schools is the Williams Avenue School, which opened in 1892. What began as a two-room school building doubled in size in 1893. A new school, which is still operating as the current school building, was built in 1918. The band was organized in 1937, and an administration building was added in 1952. This school still teaches grades kindergarten through six.

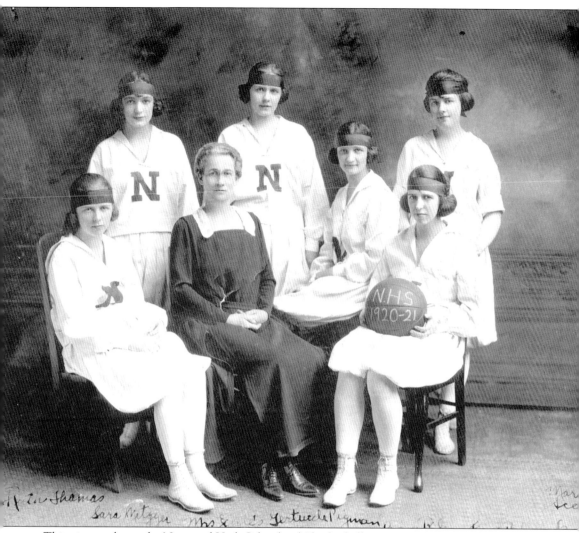

This picture shows the Norwood High School girls' basketball team in 1920–1921. The ladies in this picture are, from left to right, Ruth Thomas, Sara Metzyer, Mrs. Echles (coach), Gertrude Pigman, Bess Riley, Faye Blaches, and Marie Scanlon. Around 1903, the enrollment at Norwood High School was so small, no athletic coaches were deemed necessary. Frank Burnett, an 1899 Norwood High School graduate, helped coach the early men's football team. Another Norwood all-star was Leonard K. "Teddy" Baehr. An excellent Norwood football player, Baehr graduated from Norwood High School in 1911. He went on to make his mark as a football player at the University of Cincinnati but returned to Norwood often to help coach the early high school team. In 1915–1916, the Norwood High School men's basketball team won all nine of their games played under the first coach, L. H. Battersby.

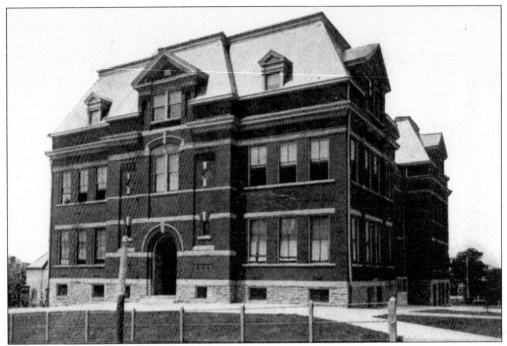

This postcard shows Marion School, one of the first schools in the area. Classes were held in a four-room brick schoolhouse on Marion Avenue. In 1893, the school changed names to the North Norwood Elementary School. In 1915, a new, fireproof building was built. In 1938, the school orchestra was established and a cafeteria was built. That same year, students ate more than 18,011 lunches. The school has now closed, and the city leases the building to the Hamilton County Educational Service Center.

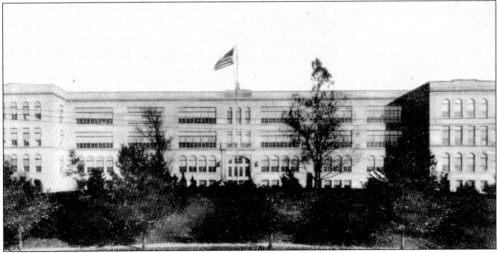

This picture shows the Regina High School, an all-girls Catholic school that was founded in 1928. The school was built in Norwood Heights next to the seminary and Archbishop Henry Moeller's home. The property for the school was donated by the Norwood Heights Company to the Catholic Church in the hopes of attracting investors to this section. Sisters of the Precious Blood operated the school for 49 years. The school closed in 1977, but its influence in the neighborhood can still be seen; several streets are named after clergy members.

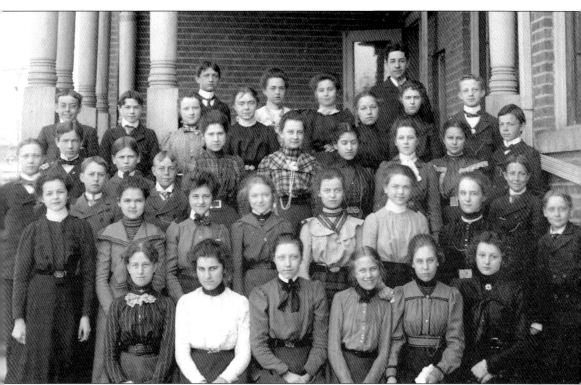

This class picture, from the early decades of the 1900s, is taken in front of Norwood's Central School. One of the Norwood school trustees was Capt. Joseph Benson Foraker. Before Foraker was the governor of Ohio (from 1886 to 1890), he was a teacher in the Norwood public school district. In 1880, he moved to Cincinnati to further his political career and became a U.S. senator after his stint as governor. Foraker was born in 1846 and died in 1917. Another Norwood resident to follow this path to success was Judson Harmon. Harmon was a Norwood teacher in 1870 and later became governor of Ohio. Harmon's father was the first Baptist preacher in Norwood, and the Harmon Memorial Baptist Church is named for him. Howard Ferris is another name from the past; he was one of the first teachers at Central School. Ferris studied law when not teaching and was nominated for a judgeship. He was voted in with a large percentage of votes.

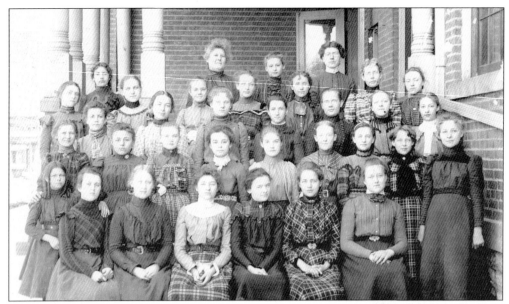

This picture, taken in the early decades of the 1900s, shows another group of Central School students. A two-story building replaced the old school in 1856. The 1884 faculty included just two teachers, and a second two-story building was built to house the increased number of Norwood students. In 1887, four more rooms were built, and in 1894, 15 teachers were on the payroll. In 1976, the faculty blossomed to 228 teachers.

This picture shows a group of Norwood High School students on the grounds of the Central School in December 1909. The school was built in 1838 and was the first to be built in the Norwood area. It was a one-room schoolhouse set on the east side of Montgomery Road near Elm Avenue, which bordered the school's south side. The west side boundary was Smith Road, and Sanker's Beer Garden sat on the north side of the school's property.

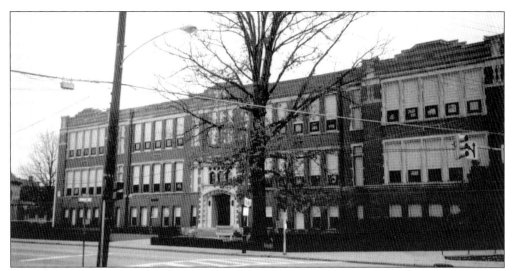

The Sharpsburg Elementary School was built in 1910 as a replacement for the Central School. It was named Sharpsburg after the original name of the Norwood village. A primary school for grades kindergarten through 12 was built in 1959 across the street from the elementary school. The primary building is now home to the Norwood Service League, Head Start, and a childcare program. Sharpsburg is known for being the first school in Norwood to install a cafeteria, which was done in 1919.

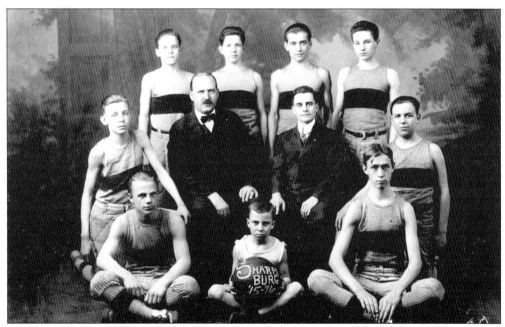

This is a picture of the Sharpsburg Elementary boys' basketball team. The Sharpsburg Elementary School still stands on Smith Road near Forest Avenue. Another early local school these boys may have had to play basketball against was the Norwood View Elementary School. The View School building was built in 1915 at Carthage and Hannaford Avenues and has had many additions to it since. In 1929, two rooms and an auditorium were added on, and four more rooms were built in 1934. A primary wing was added in 1953.

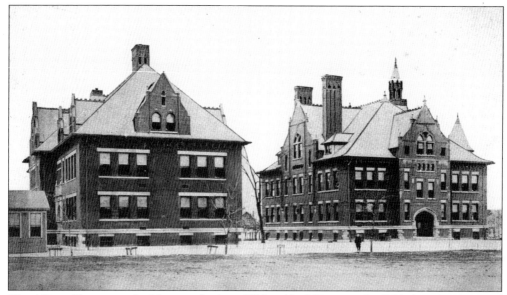

The Allison Elementary building was built in 1896 and had 12 rooms. In 1901, the school opened a high school in an old building that was already on the property. The elementary school grew and in 1914 took over the high school to use for extra classroom space. The old house burned in 1917, and a new 12-room structure was built to accommodate the elementary school.

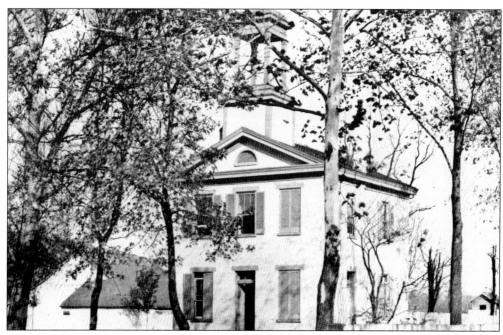

This is a picture of the first schoolhouse in Norwood. Pioneers to this area include Columbus Williams, Thomas Drake, W. B. Ferguson, Moses F. Buxton, Tunis Van Middlesworth, David Woolley, Justus Durrell, and Rev. Jason Lyon. Also, a man named Joe Langdon moved here in 1840 and claimed to have found a bullet from Mad Anthony Wayne's campaign.

Two

SOURCES OF SPIRITUALITY

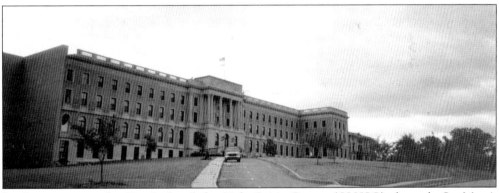

In this picture is the Our Lady of the Holy Spirit Center (OLHSC), formerly St. Mary's Seminary. This building was built between 1921 and 1923, but its history dates back to 1907, when Archbishop Henry Moeller accepted 16 free acres from the Norwood Heights Company. In 1908, the archbishop announced plans to build a home on Moeller Avenue. Construction on the seminary did not start until 1921 and cost $750,000. When the seminary opened in 1923, approximately 180 students enrolled in the four-year theology school. Fr. Richard Willhelm, who attended the seminary in the 1940s, bought the structure and surrounding acres in 1992 for $100,000. He wanted to turn it into a retreat and spiritual center, as well as a place for retired priests to live. Willhelm changed the building's name from Mount St. Mary of the West to the Monk's Retreat Center. Willhelm died in 1993, and the center's name was changed to the present-day OLHSC on May 1 of that same year to encompass all the activities planned for the 300-room building.

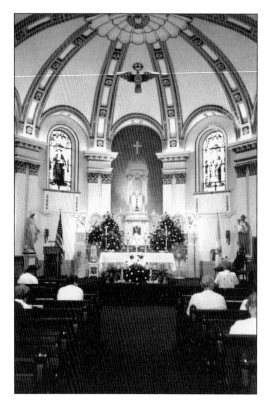

This picture shows the Holy Rosary Chapel inside the present-day OLHSC. The main chapel area was recently refurbished and can now seat 500 people. The main altar came from the former Holy Cross Monastery in Mount Adams, which closed in 1970. Lights hanging in one section came from the old St. Xavier High School when it was located in downtown Cincinnati. There is even an old bowling lane in the basement of the building.

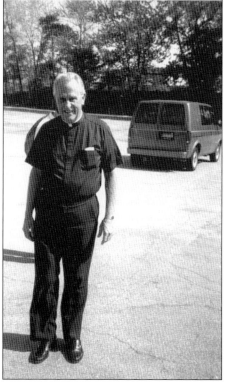

Fr. R. Leroy Smith was the president and spiritual director of the OLHSC from March 1993 until recently. Smith was ordained on June 5, 1954, and worked for 12 years as a vice rector and teacher at St. Pius X. He traveled to Medjugorje in October 1988 and has said that this trip helped deepen his spirituality. Fr. Joseph A. Bruemmer is the current OLHSC president.

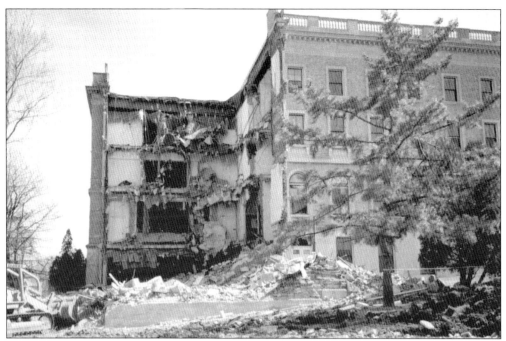

This picture shows the demolished west wing of the OLHSC. The entire three floors collapsed at 2:00 p.m. on Tuesday, March 22, but no one was injured. The collapse was caused by deterioration, speeded up by water that had leaked into the basement and was allowed to sit.

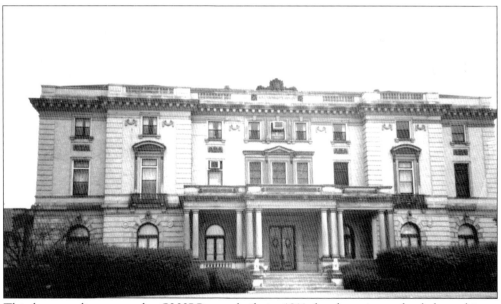

This house, adjacent to the OLHSC, was built in 1911 for the priests who led worship at St. Mary's Seminary. In the early 1990s, many religious believers gathered at St. Joseph Church in Cold Spring, Kentucky, to view an apparition of Mary, which was predicted by a visionary. But in August 31, 1995, massive roadwork around St. Joseph Church threatened to clog the roads, so the group gathered at the OLHSC in Norwood for the event.

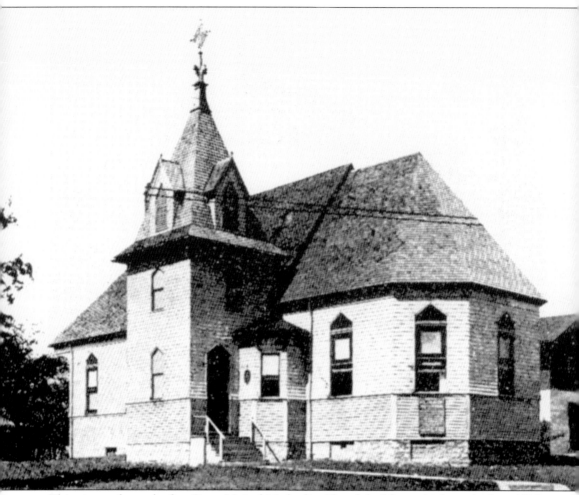

This picture shows the first Grace United Methodist Church building, which was built in 1886. Before this church was built, the congregation met in homes and later at the Ivanhoe railroad station. A vacant house was donated by William C. Baker for services soon after, and in 1884, a Sunday school was organized. John Wesley Baker was its first superintendent. On April 1, 1885, land on Ivanhoe Road was donated by the Durell brothers, on the condition that the church stay at this site for 15 years, at which time the religious organization would own the land. This building was dedicated June 6, 1886, and was originally called the Ivanhoe Methodist-Episcopal Church. A new, larger church was needed in 1905 due to increased attendance, so this building was eventually sold to the Norwood English Lutheran congregation for $3,500. One of the first official ministers was Alpheus B. Austin, who served from 1888 until 1892 and was paid $300 a year for his services. W. R. Locke, an early parishioner, was both instrumental on building committees and active in the Norwood community.

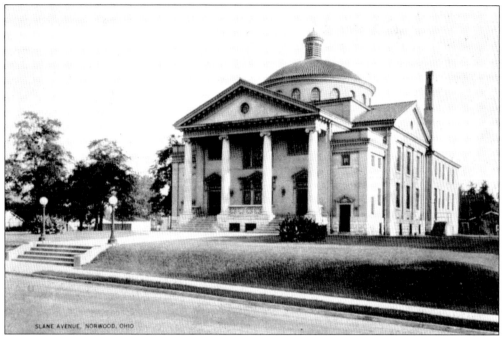

The Grace United Methodist Church bought land on Slane Avenue, and a new church building was dedicated on June 11, 1911. That same year, the church's name was changed from Ivanhoe Methodist Episcopal Church to Grace Methodist Episcopal Church. Charles C. Peale was the church's pastor from 1905 to 1910. Charles's son, Norman Vincent Peale, was a well-known author and minister who wrote *The Power of Positive Thinking* and *The Power of E*.

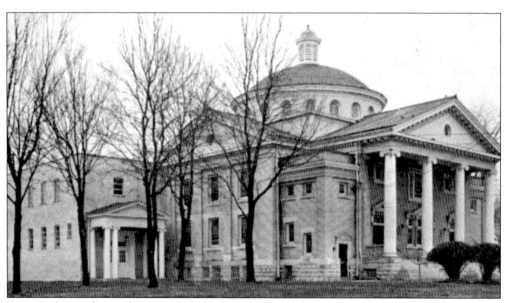

In 1953, due to the unification of Methodist Churches of America, the church's name changed again to simply Grace Methodist Church, which it continues to be called. In 1954, the building and the sanctuary were remodeled, as seen by this picture. The church still holds services at 2221 Slane Avenue.

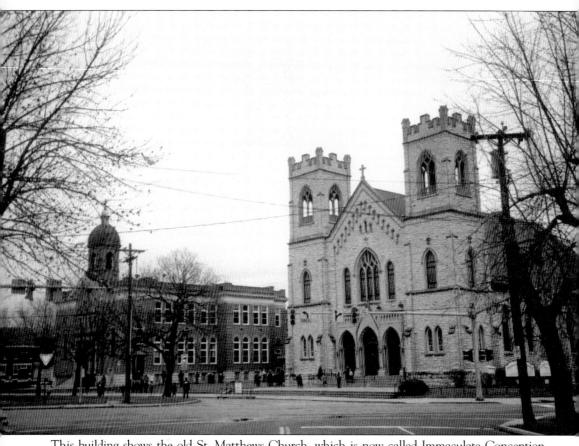

This building shows the old St. Matthews Church, which is now called Immaculate Conception Church. Due to an increase in Catholic residents in the early decades of the 1900s, Archbishop Henry Moeller appointed Fr. Frederick Gallagher first pastor of St. Matthews Church on November 4, 1906. It was then Gallagher's responsibility to organize a congregation and build a church. In April 1910, construction ended on a structure on Floral and Kenilworth Avenues that included a church with seating for 350 and a school capable of holding 200 children. The St. Matthews parish quickly grew, and a new church was built at its present-day location at 4510 Floral Avenue, next to the Sharpsburg Elementary School. The dedication was held on April 27, 1924. Another addition to the St. Matthews school was built in the 1950s, again due to increased attendance. In later years, attendance dropped and St. Matthews closed; parishioners now attend mass at Holy Trinity. In 2006, this building is home to the Immaculate Conception Church and Immaculate Conception Academy.

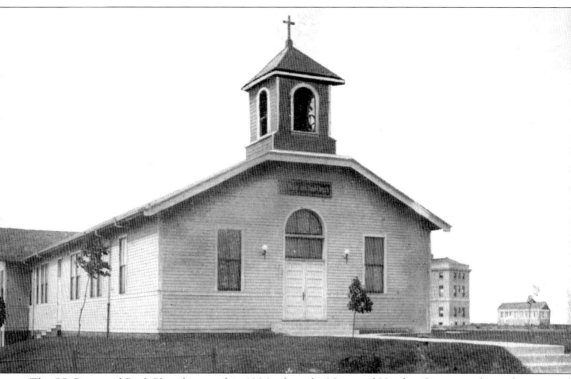

The SS. Peter and Paul Church started in 1906, when the Norwood Heights Company planned a suburban community that attracted many Catholic families. The first mass was held on October 28 of that same year in the First National Bank Hall, and subsequent services were held in a large storeroom at 4936 Montgomery Road. The congregation made plans to build a church and a school. Construction started in the spring of 1907, and the dedication was on July 21 of that same year. This small church was built on Montgomery Road and seated 350 people. Classes were held in three small rooms at the back of the church. In September 1907, 26 children attended classes. There were 50 students by the end of the year. An old farmhouse was remodeled in October 1907 for Father Beckmeyer to live in, and a sisters' residence was built in 1910. A new SS. Peter and Paul school opened in February 1922 at the corner of Moeller and Drex Avenues.

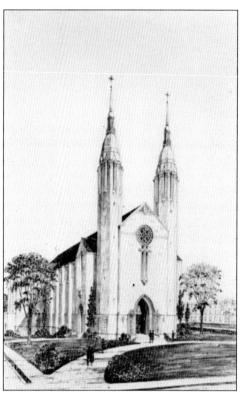

The new SS. Peter and Paul Church building was dedicated on June 30, 1940. The two steeples are dedicated to St. Peter and St. Paul. A decline in church attendance caused three Catholic church parishes to close; SS. Peter and Paul, St. Matthews, and St. Elizabeth. Remaining parishioners now attend mass in the SS. Peter and Paul building, which has been renamed Holy Trinity. Two Peter and Paul statues stand outside the church, and the school remains open.

This picture shows the first Roman Catholic church in the area, St. Elizabeth Roman Catholic Church. Catholic families met in the summer of 1884 to discuss building their own church. On August 31, 1884, the group met at J. Stephen Bokenkotter's house on Allison Street to organize. Some of the men at that meeting included Bokenkotter, Philip Moessinger, Joseph Mersch, Peter Ritter, Joseph Wissman, and Joseph F. Fritsch.

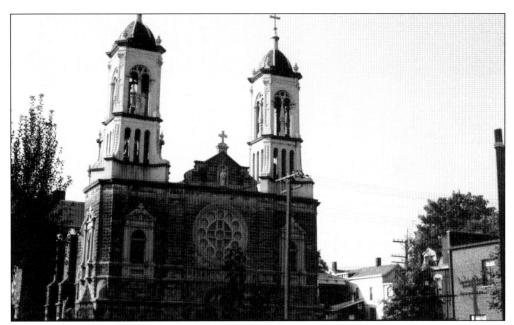

A plot of land was donated for the St. Elizabeth parish at its present-day site on Mills Avenue. The first structure was blessed on Sunday, October 3, 1886, by John C. Albrinck. Albrinck and his assistant, Rev. Charles Hahne, celebrated masses until a permanent pastor was appointed in 1887. Construction started on a new church on July 13, 1901, and was dedicated on May 17, 1903. The school opened November 26, 1914.

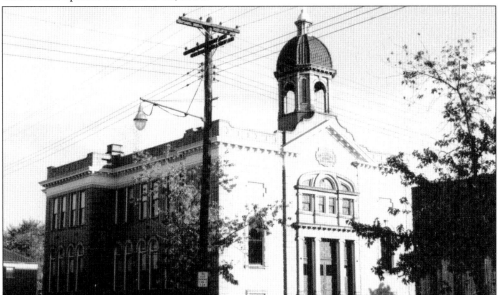

This is a better picture of the St. Matthews school, which is currently the Immaculate Conception school. In 2006, Norwoodites can visit the community center, which is in the nearby old St. Elizabeth Church. The original name for St. Elizabeth was the Most Holy Redeemer. It was changed to St. Elizabeth after a request by the archbishop at the time. Historians suspect the name change was to honor Elizabeth Fritsch, whose husband dedicated most of his time to organizing and initiating the building of the church.

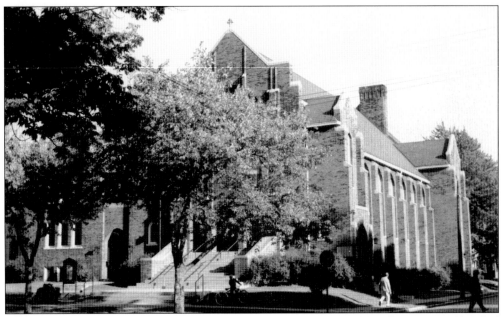

This is a picture of the Norwood Presbyterian Church. When the village was still called Sharpsburg, religious services were often conducted in neighbors' homes and services were not limited to the teachings of a particular religious sect. Attendees were Methodist, Presbyterian, Baptist, and others. Henry Ward Beecher, Harriet Beecher Stowe's brother, often led many of these homestead services. Henry lived in nearby Walnut Hills and attended Lane Seminary.

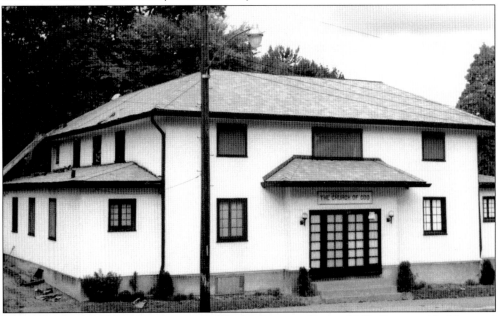

This Church of God building was originally the Pirouette Dance Hall. One notable Norwood pastor was Dr. William G. Everson, who preached at the Norwood Baptist Church from January 16, 1916, until the outbreak of World War I. He enlisted as a chaplain in the army and worked until the end of the war. Two other notables are J. A. Lord and Alva W. Taylor of the Norwood Christian Church.

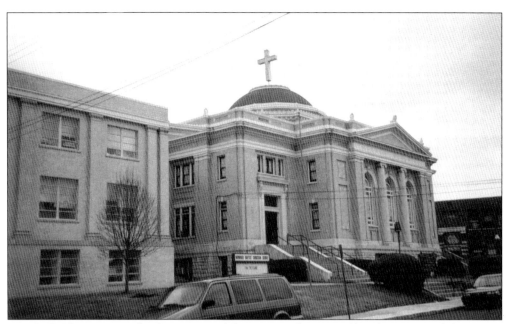

Rev. B. F. Harmon was the first pastor of the Norwood Baptist Church. He served from 1889 until his death on June 8, 1893. During his tenure, Harmon lived in the Lauterbach homestead. On April 19, 1892, a new church on the northwest corner of Sherman and Station Avenues was dedicated. This picture shows the present-day church building at 2037 Courtland Avenue that was dedicated on October 14, 1919.

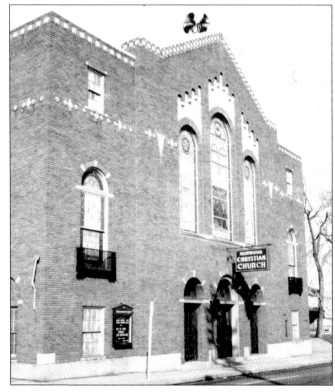

The Norwood Christian Church was built in 1897, after Elkana Meyers, a Norwood resident, first proposed the idea in July. Rev. A. M. Harvout, the Christian Missionary Society, and the Richmond Avenue Christian Church were early supporters. The first congregation met on December 5, 1897, and in May 1908, a lot was purchased at Washington Avenue. Construction for a new building started on November 5, 1911, and was dedicated on April 12, 1914.

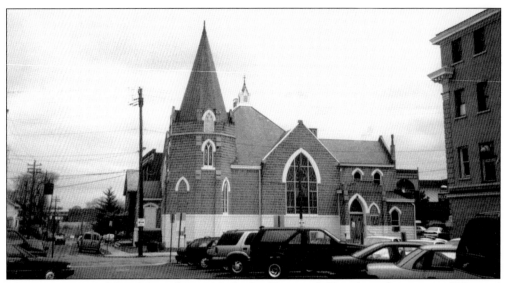

This is a picture of the Norwood First Methodist Episcopal Church at the corner of Elm and Station Avenues. Other Norwood churches included the Zion Evangelical and Reformed and the Chancel Window Lutheran Church of Our Savior.

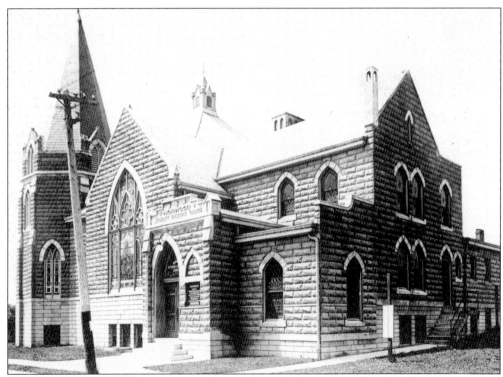

This is a better shot of the Norwood First Methodist Episcopal Church. This congregation started in 1884, when a group of early Methodists met for church services at the Norwood Town Hall, typical of many early church groups. Rev. G. L. Tufts was the first pastor, and the Wooley and Arnold families donated land at the corner of Harris and Wesley Avenues. Construction started on August 11, 1885, and the cornerstone was laid on September 28 of that same year.

Three

GIVING BACK

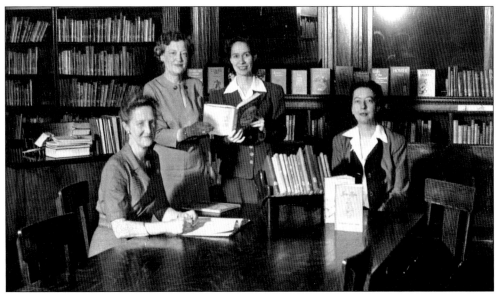

This picture was taken around 1945 for "Mr. Hadley's Book of Memories." In it, from left to right, are Frances Clarrow; Frances McClelland, the Norwood branch librarian; Elizabeth Redings, the child librarian; and Helen Rapp Sinneckson, the administrative assistant. McClelland was a library fixture; she worked for the Cincinnati Public Library for 40 years, including stints at the Pleasant Ridge and Hyde Park branches. But her stay at Norwood was the longest—she worked as head branch librarian from 1944 to 1957. She officially retired on February 4, 1958, and passed away on June 27, 1974. Her nickname was "Miss Mac," and she collected historical information and newspaper clippings about the area. This was the start of the Half-Century Club—a club whose members included citizens who had lived only in Norwood for at least 50 years. The Norwood Historical Society was officially founded in May 1978, after a meeting with Mayor Don Prues and Sophia Prevey, a newcomer to Norwood interested in saving some of the old Norwood Victorian homes.

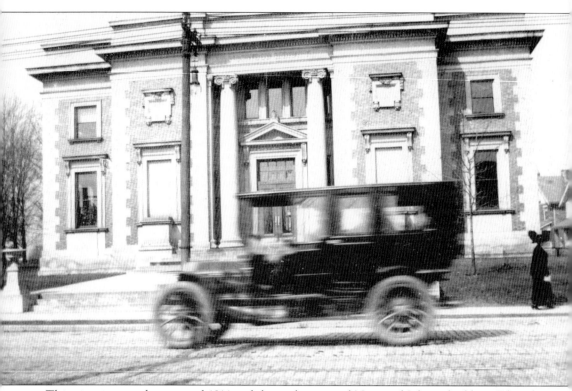

This picture was taken around 1914 and shows the original Norwood Library building. Edward Mills donated a 120-foot-by-173-foot lot on the corner of Weyer Avenue and Montgomery Road for the library, and $23,000 in grant money from the Andrew Carnegie fund helped get construction started. Building got underway on October 1, 1905, and the library was officially opened for business on July 22, 1907. The Norwood mayor at that time, Charles Jones, oversaw the organization and building. The early library enjoyed success, especially during the Great Depression (1932–1935), since patrons had no money to buy books at stores. The first librarian was Lillian David, daughter of Judge David Davis. David Davis lived in a house at 1911 Mentor Avenue and was the third mayor of Norwood, serving from 1894 to 1897. He was Norwood's first solicitor in 1888 and resigned as mayor to work as a judge of the Court of Common Pleas. He married Alice E. Sutherland on January 8, 1880, and the couple had four daughters.

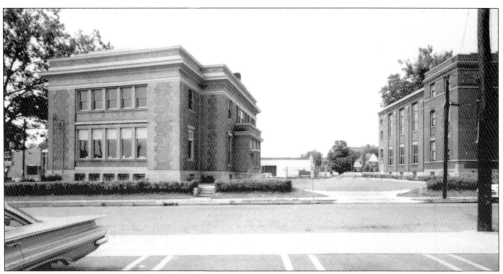

This picture was taken on July 4, 1966, after the library was restored a second time. Note the new 13-car parking lot in the rear of the building, which is still in use in 2006. The renovation in 1966 cost $108,664 and added an entrance along Montgomery Road. The building was rededicated on Sunday, January 30, 1966, at 2:30 p.m. Catherine Clement was the librarian at the time.

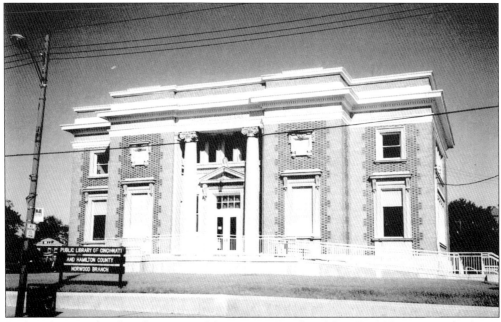

In this photograph taken from across Montgomery Road on May 17, 1998, one can clearly see the Norwood Library's new wheelchair access that was completed in December 1997. Mayor Joe Hochbein and Mary Kay Livesay were on hand for ribbon-cutting ceremonies. The library underwent a third series of renovations in 2001, and, in 2002, the library won two awards—the Griffin Yeatman Historical Achievement Award and the Cincinnati Preservation Association Award—for historical preservation contributions.

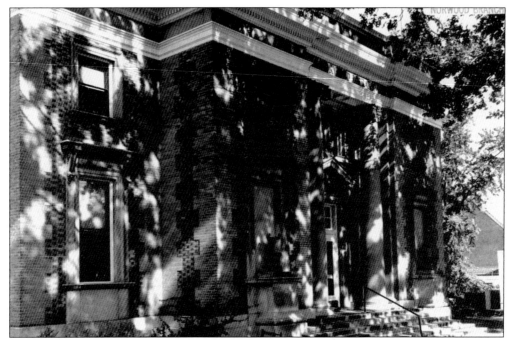

This picture clearly shows the Rookwood pottery urns that adorn the outside of the Norwood Library. Fred Schwenck donated the urns, probably around 1938 during his tenure as a library trustee. (A 1937 picture of the library shows a pair of small, potted plants sitting where the urns now sit.) At some point, the urns were taken down and stored in the basement of the Norwood Library. During the library's restoration in 2001, the urns were restored, and in 2006, they sit proudly inside the library.

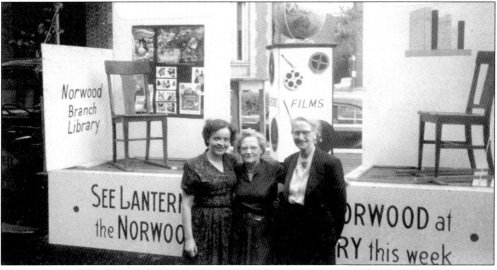

This picture of the library float in Norwood's 50th anniversary parade was taken on May 6, 1953. Hilda Kern, Frances McClelland, and Frances Clow stand from left to right. The Norwood Library celebrated its 75th anniversary on October 9, 1982. One of the honorees at the event was 93-year-old Elsie Landess. In 1907, as an 18 year old, Elsie was sent to Norwood to help open the branch library by setting up the card catalog and organizing all 8,541 books.

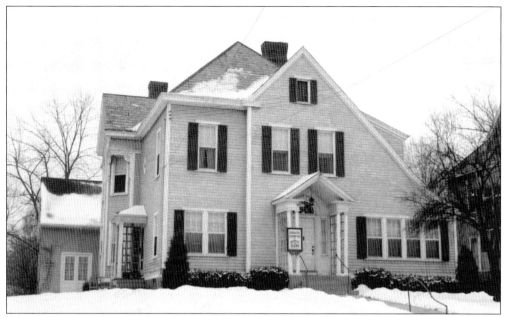

The National Federation of Women's Clubs organization held their meetings at this house on Slane Avenue. In 1898, books were being delivered to Norwood from the main library, but there was no official library. So the Federation of Women's Clubs of Norwood actively pursued obtaining one. Some clubs in this organization were the Junior Research, Norwood Teachers, and the Norwood Girl Scouts, which Juliette Low founded in 1912.

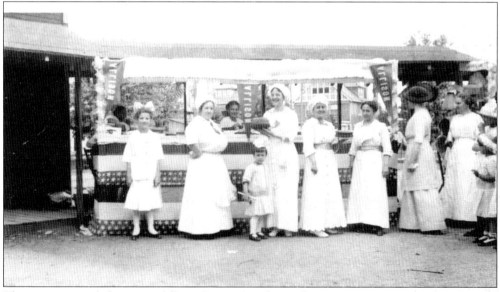

This is a picture of a bazaar on Allison Street. Another early community group was the Norwood Town Hall Ladies. This society formed in 1878 at Dr. Gratigny's home. Yearly dues were 10¢. The group held fund-praisers and social events such as concerts, luncheons, and suppers. One community get-together was held at Col. Philander Parmele Lane's house. The society stayed together until at least 1887. After that, records are incomplete.

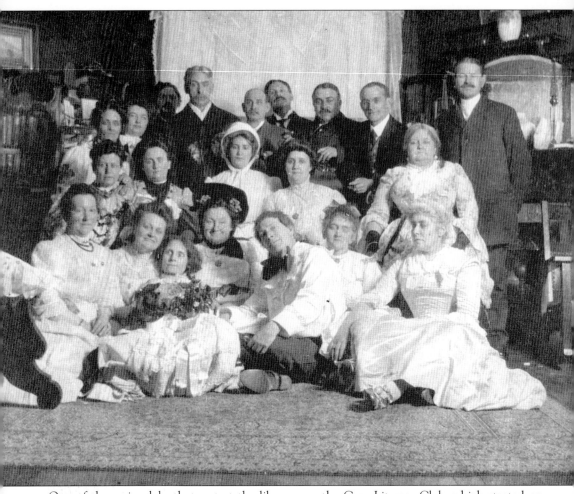

One of the main clubs that met at the library was the Cary Literary Club, which started on January 29, 1898, to provide women with an opportunity to gather and discuss social events, literature, and music of the day. The club, which was originally named the Fortnightly Literary and Musical Club, was started by Mary Alice Kemper. Kemper invited eight ladies to her house and asked each attendee to bring one friend. They gathered every two weeks from October through June. In 1899, the name changed to honor Alice and Phoebe Cary, two famous poets from College Hill at that time. In time, the club evolved to giving book reviews and collectively writing a book. The group also volunteered, donated large sums of money to local schools or organizations, hosted banquets, and threw parties. The club celebrated its 60th anniversary on May 12, 1958, then disbanded because older members were having a difficult time making it to the meetings.

Jessie V. Wilson, pictured here, was the last surviving founding member of the Cary Literary Club. She was in the first class to graduate from Wyoming High School—and outlived all her other classmates—and was a member of the Ohio Federation of Women's Clubs, where she was recognized as being both the oldest member in age and in length of membership. She was asked to be the special guest at the 60th anniversary of the Cary Literary Club, but her poor health kept her from attending the ceremony. She died at 91 on May 18, 1958. Her husband, William B. Wilson, was active in early Norwood politics when the city was still a village. The couple had one daughter and one son, Ethe Ringland and Rev. W. W. Wilson. Officers of the club in 1900 to 1901 included Cora T. Molloy (president), Mary Mackenzie Miller (vice president), Jessie S. Wilson (secretary), Jessie V. Wilson (corresponding secretary), and Matilda Rebhun (treasurer). The Music Committee included Matilda Rebhun, Ida May Mulford, and Mary F. Rockwell.

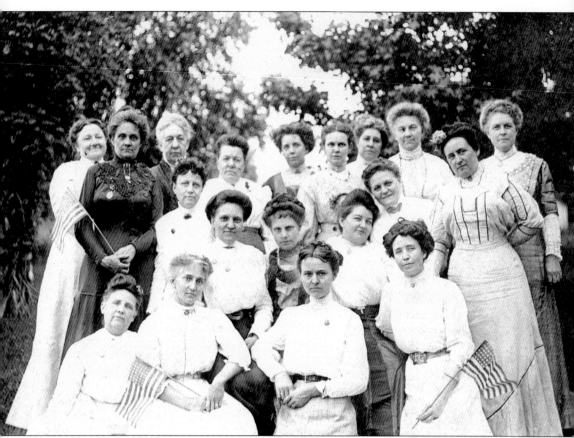

In this picture of the Cary Literary Club, Matilda Rebhun and Jessie V. Wilson sit left to right on the far left in the front row. The other two ladies sitting behind them are unknown. The middle row of ladies who are still sitting, from left to right, are Ida May Mulford, Cora Molloy, Jessie S. Wilson, unidentified, Marie E. C. Folger, and Mrs. E. Nelson High (who is standing). Standing in the back, from left to right, are Mary F. Rockwell, Mrs. W. G. Betty, and five unknown ladies. The last two women standing in the back row are Mrs. Bloomfield and Mrs. Thompson from left to right. The Cary Literary Club had its own theme song, and the chorus went like this: "There are many clubs in many lands / There are clubs of every name / But there is no club in any land / With our Cary Club's fair fame." The song continues for at least four more sections.

The group often had picnics or yearly parties, where spouses and children were invited. The ladies published their first yearbook in 1899. In the second edition, the ladies describe a typical gathering: On October 6, Mrs. Singer was the hostess. The group started with roll call, Mrs. Bell reviewed the list of current events, music was played, Mrs. Miller spoke about "Paper—'Books,'" and Mary F. Rockwell read from "Book Lovers' Euchiridion." Meetings concluded with a poem or grammatical test.

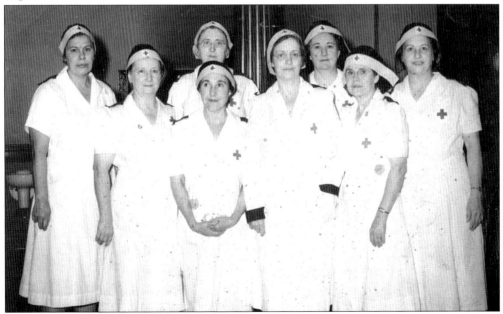

This 1942 picture is of a group of Red Cross female volunteers working on bandage rolling in the Norwood City Hall to help support the Red Cross during World War II. Lillian Roudebush (wife of Mayor Allen Roudebush) and Olive G. Gibson stand in the front row, fourth and fifth from the left. Lillian Roudebush was the leader of the group. The first lady in the back row (with glasses) is Ruth Wolf.

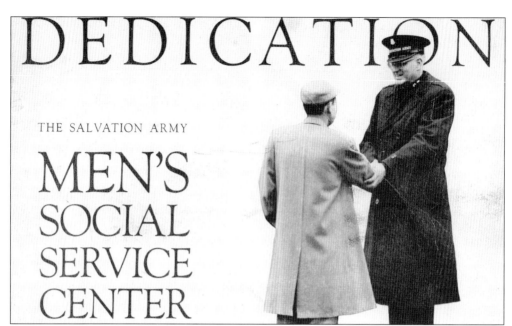

This is a brochure from Norwood's Salvation Army dedication on Sunday, April 23, 1961, when the divisional commander was Lt. Col. William E. Chamberlain. In 2006, the center continues to be the only Cincinnati-area adult rehabilitation center. Men in the rehabilitation center spend their days going to classes and working. The organization accepts clothing, furniture, magazines, and other usable merchandise, which they resell.

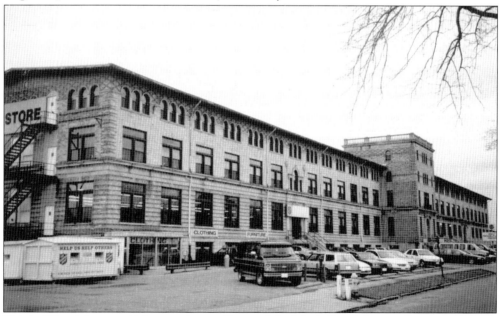

This building is home to Salvation Army offices and the Men's Social Service Center—100 beds for men recovering from various addictions, including dependencies on drugs and alcohol. This building originally belonged to the Osborne-Kemper-Thomas (OKT) Company. Guido R. Kemper and D. Carrill Thomas formed the OKT Company in 1883 in downtown Cincinnati under the name Kemper-Thomas. The company moved to this building on Park Street in 1902.

This brochure showcases the American Legion follies. One of the legion's initial duties was to honor Leland M. Barnett, the first Norwood soldier to die in World War I, by naming the Legion Post No. 123 after him. November 11, 1919, marks the legion's first meeting at Norwood City Hall. Exactly one year later, on November 11, 1920, an auxiliary for women members was instituted at Norwood City Hall. In 1947, the legion boasted a 500-person membership of World War I and II veterans.

The first officers of the American Legion were Comdr. W. C. Meyer, Vice Comdr. D. E. Evans, treasurer Charles A. Mauer, and adjutant E. R. Knauft. Members of the executive committee included C. L. Loos, C. A. Neal, G. W. Crowther, W. S. Gwynn, C. Meyers, M. Brown, and L. Frey. The legion often repaired and painted toys, which were then given to the Norwood Service League to give as Christmas gifts.

E. B. Danson was the first chairman of the Norwood Service League (NSL), a group formed during World War I to help affected families. Danson served as head of the group from 1917 to 1919, along with Will C. James and John O. Omwake. Danson was also the president of the Kemper-Thomas Company. During his reign, the company started making items out of cloth and leather and other novelty specialties printed with promotional text.

Will C. James served on the NSL board from 1917 to 1919 as the secretary-treasurer and from 1928 to 1930 in various other positions. In the early years of the NSL, the organization was nicknamed "Team Y." This is because the early volunteers who worked at the Liberty Loan Drives from 1917 to 1918 came up with the slogan, "Put the Y in Victory." James worked at the Kemper-Thomas Company with Danson.

John O. Omwake also served from 1917 to 1919 and in 1928. Omwake's day job was as the president of the United States Playing Card Company. The first headquarters of the NSL was located in a small room in city hall. In 1922, the league moved to a house at 2155 Washington Avenue, where it stayed until 1926.

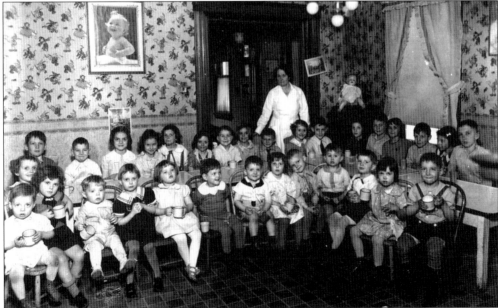

By the end of the war, the NSL had become so popular that it continued offering support to community members. In 1918, the NSL joined the Norwood Community Chest to continue offering family support and a day nursery, which is shown in this picture. While the older children went off to school, the younger kids had an orange juice and crackers break at 10:00 a.m. At noon, lunch was served for all, and nap time was at 2:00 p.m.

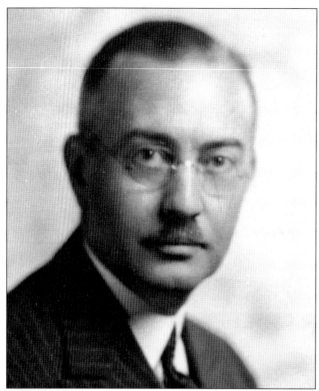

Stanley W. Allen, in this mug shot, was the general chairman of NSL in 1930. He worked in other positions on the board during different years, including group chairman in 1931 and 1934. Earl R. Knight served as the citizens chairman during Allen's reign in 1931. In 1927, Allen took over as president of Kemper-Thomas after Danson's death. In 1952, Allen became chairman of the board of Kemper-Thomas and served until his death in 1956.

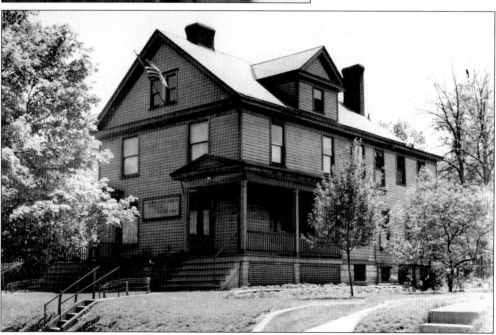

This picture shows the house at 2071–2073 Lawrence Avenue where the NSL ran its operations from September 1927 until 1972. In July 1927, Sidney Irving Crew donated a swimming pool to the children attending the NSL day care. In the early months of 1927, the league moved to 2937 Sherman Avenue, where they only stayed for only a short time before moving to this house.

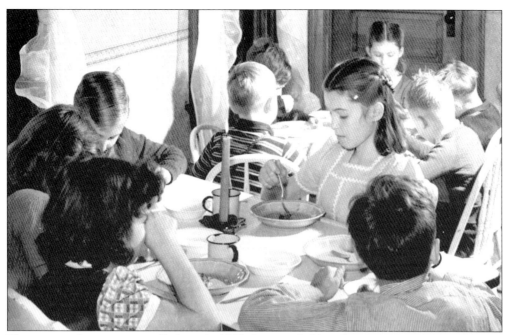

This picture shows a group of kids at the NSL day care, held at the Lawrence Avenue house. In 1927, members at the NSL worked on more than 300 cases. Approximately 18 children came to the nursery on a daily basis. The league operated with a budget of $27,000. Ten years later, in 1937, the league took care of 37 children in the nursery and handled almost 600 cases.

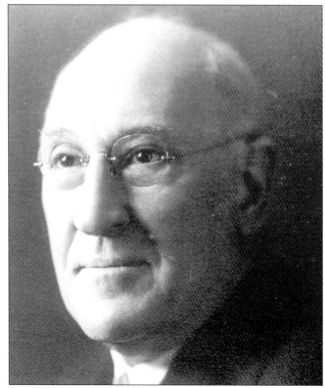

Theodore "Teddy" C. Dorl was group chairman of the NSL. He was on the board from 1920 to 1921 and again in 1934. He was also an executive at the United States Playing Card Company and an art lover who commissioned many Cincinnati artists to produce artwork for the playing cards. On October 11, 1941, Dorl Field was named after him as a memorial.

Edward G. Schultz was general chairman of the NSL in 1922. Another famous Norwood Schultze was Mildred Schultze. Mildred lived on Floral Avenue and was a well-known early historian of the area and librarian of the Half-Century Club. Mr. and Mrs. William Rohdenburg formed the club, which eventually turned into the Norwood Historical Society.

This is a picture of Dr. J. C. Cadwallader, who was the general chairman of the NSL in 1923. Cadwallader practiced medicine at 4320 Montgomery Road, across from the Norwood Library. The structure was later known as the Cadwallader Building. The other offices in the building during Cadwallader's time were rented to another doctor and a group of dentists.

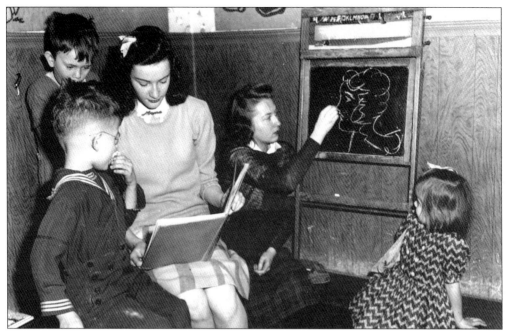

In this picture, Norma Keudrick and Harriet Wolf (now Harriet Arnold), who were each 15 years old, help teach these three young children at the NSL. The kids' names are David Sparks, age 5; James Niemeier, age 6; and Mary Francis Mies, age 5. Recreation opportunities were also offered at the organization, including indoor games, group sing-alongs, and outdoor sports.

Willard E. Thayer was the NSL's citizens chairman in 1929. H. N. West was the group chairman in that same year. Before these two men, Arthur W. Fischer served as the citizens chairman in 1923 and 1924, and Rev. George T. Lawton served as general chairman from 1925 to 1926. A year before Thayer served, O. DeGray Vanderbilt Jr. was the general chairman in 1927 and 1928.

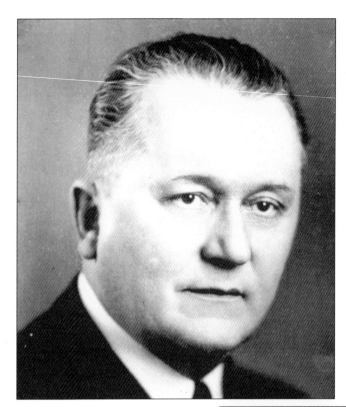

This picture is of Erwin S. Mason, who was the citizens chairman of the NSL in 1932. During the same year, Theodore C. Dorl was on the board. Richard E. LeBlond served as group chairman both that year and in 1933. Before these two men, George Guckenberger performed the role of citizens chairman in 1930.

On the first Monday of every month, pediatrician Dr. Gerritt W. Raidt (whose arm can be seen in the picture) gave all the children complete physicals. By 1939, the nursery was on a set schedule, offering its services to working women. At 7:00 a.m., the doors opened, and they closed at 5:00 p.m. Older children went off to school around 8:00 a.m.

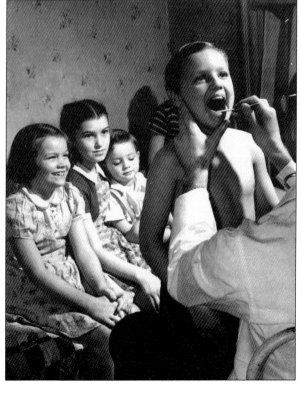

Raymond J. Dierker was the citizens chairman in 1939. His cabinet included Frank J. Ward, vice chairman; John J. Braun, treasurer; and Julius L. Thorn, secretary. Will C. James, Rev. W. O. Cross, and Mayor Allen C. Roudebush made up the rest of the board of trustees. Honorary members include Rev. George T. Lawton, John O. Omwake, and Theodore C. Dorl; the latter two were deceased at the time.

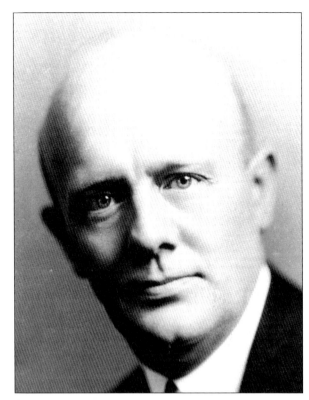

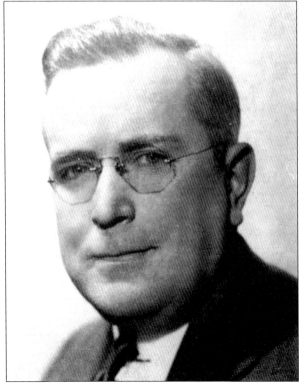

Frank J. Ward was the citizens chairman in 1938. Virginia Roessler Ward, believed to be his wife, was the general chairman in 1919. Another Norwood do-gooder was Jacob G. Schmidlapp, who owned the Schmidlapp Apartments at 2715–2741 Harris Avenue. The buildings were built from 1911 to 1912. Schmidlapp rented the 28 three- and four-bedroom apartments at lower prices to locals in need.

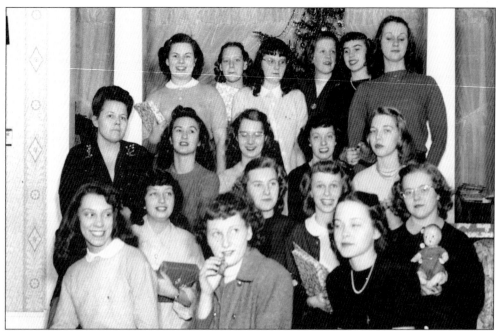

This picture shows a group of volunteers from the NSL who helped a local needy family celebrate Christmas in the 1930s or 1940s. From 1932 to 1934, food was distributed to needy families at the old Market House in Victory Park. Other nonprofit organizations that have developed in the area include the Norwood Lodge No. 301 L.O.O.M. (Loyal Order of Moose) and the Leukemia and Lymphoma Society.

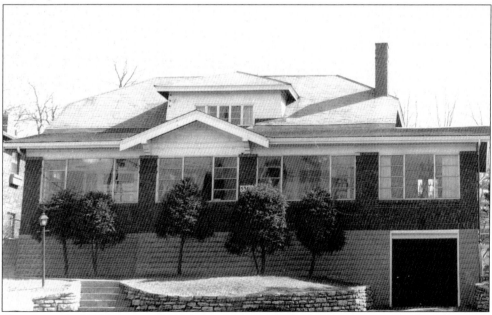

This shows the NSL house at 5300 Montgomery Road. The league moved to this house in 1973, and the Norwood Kiwanis Club built a fence for the league's on-site playground. In 2004, the day care closed due to lack of funding and increased demands from the state. In 2005, the league moved into the Sharpsburg Primary School building, where it remains today.

Four

NEIGHBORHOOD EVENTS

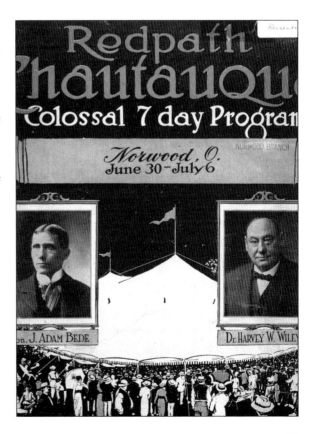

This 1914 program advertises the Red Chatauqua, an organization that used to host tent performances during the summers in Norwood. Sometimes the actors performed Shakespearean plays; in this program, for example, they advertise their production of *The Taming of the Shrew* as one of their best shows of the season. The troupe of 13 actors called themselves the Ben Greet Players, to honor the name of their theater coach. George Vivian was the lead actor and was therefore in charge of the troupe. Vivian moved from London, where he had appeared before Great Britain's royal family, to America in 1904. Besides theatrical performances, the tents were also used as public-speaking platforms. This program boasts of Dr. Harvey W. Wiley, who spoke about "unadulterated foods unhampered in any way by governmental red tape." Season tickets were $2 for those who got them early; after a certain number were sold, the price went up to $2.50.

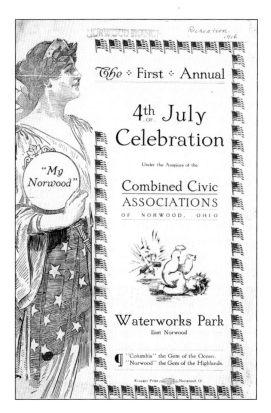

This brochure advertises the Combined Civic Associations' Fourth of July party in 1916. Norwood celebrated the bicentennial in 1976. In that year, the students of Norwood High School put together a book titled *Norwood, Ohio: A Bicentennial Remembrance*. The students used an unpublished manuscript, *A History of Norwood Ohio*, written by Allen C. and Lillian Roudebush as a basis of their research, and Margaret Guentert edited the book.

On September 19, 1930, Norwoodites dedicated the new Main Avenue. Felix Levy, president of the Norwood Retail Merchants' Association, presided over the events. The Norwood High School Band played music to accompany the festivities, and Rev. Fred C. Schweinfurth and George Bundy spoke. A "masque" parade and Mardi Gras party followed the dedication ceremony. The festivities continued on September 20 with a grand pageant and parade.

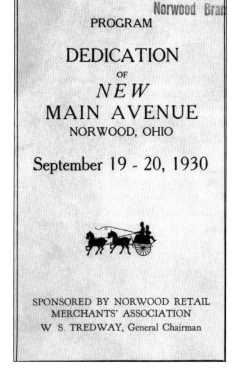

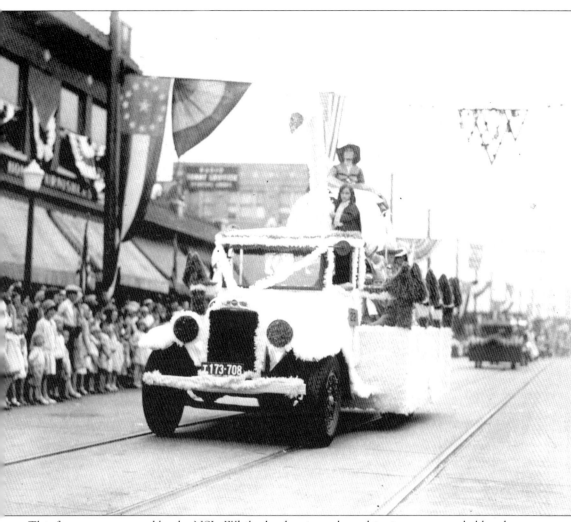

This float was sponsored by the NSL. While the date is unclear, this picture was probably taken at one of the inaugural Norwood Day parades. Aaron McNeil, the Norwood mayor from 1891 to 1894, is credited with founding Norwood Day, a parade and celebration of the area. On April 16, 1894, McNeil spoke to the village council and set aside June 9 to celebrate the completion of the waterworks system. The parade is now in its 114th year. McNeil lived at 1934 Hopkins Avenue, and is known for improving the volunteer fire department, fixing the streets of Norwood, and starting the waterworks system. Norwood's population grew to 6,000 by the time McNeil retired in 1894, even though he did not complete his final term of office. Instead, he opted to sit on the bench of the Court of Insolvency, at that time a newly formed arm of the justice system.

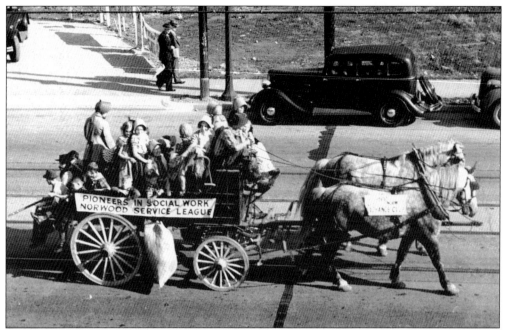

This picture was also taken at a Norwood Day parade in the early decades of the 1900s. Other men who served during Aaron McNeil's mayoral term were John C. Masker, treasurer; W. E. Wichgar, clerk; and W. E. Bundy, solicitor. Another interesting tidbit is that Dr. T. V. Fitzpatrick, a Norwood mayor from 1896 to 1899, lived next door to McNeil.

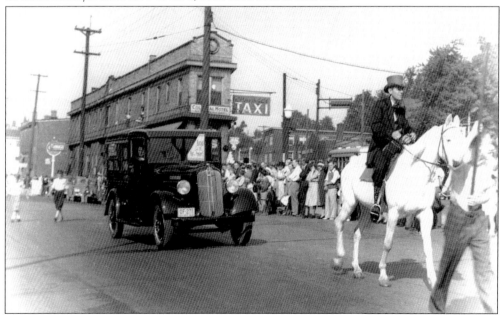

This picture shows a Norwood Dary parade in 1938. In this picture, the man on the white horse is portraying Timmy Flint—an early minister who distributed literature to Norwood neighbors in the early 1820s. While Flint did not work for the library, he may have planted the seed for one. By 1898, employees from Cincinnati's Main Library delivered a variety of books and literature to the J. L. Vine drugstore, which sat at Main and Maple Avenues.

Norwoodites held this parade to celebrate Japan's surrender to the United States in 1945. Here a man holds up a newspaper picture of the event. He is standing at the corner of Montgomery Road and Elm Avenue. The first parade was attended by residents who came to the parade site on Montgomery Road in buggies, carriages, horse-drawn wagons, on foot, or by railroad.

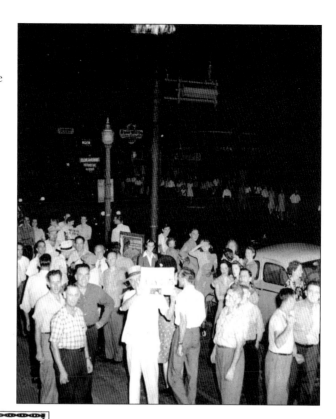

Spring Concert

Given By

Mothers Choral Club

Tuesday Evening, March 16, 1937

Eight O'Clock

At The

Norwood High School

ASSISTING SOLOISTS
Mr. Walter Pulse Tenor
Mr. E. K. Povenmire . . . Reading
Miss Helen Gough . . . Violinist

ACCOMPANISTS
Mrs. Fred Hegner
Mrs. Grace Hamilton

DIRECTOR
Miss Pearl E. Ewing

This brochure showcases a spring concert presented by the Mothers Choral Club. The group sang 20 songs. Some women in the club included Mrs. W. Engel (second soprano), Mrs. H. Otis (first soprano), and Mrs. W. E. Jamison (alto). Another company that advertised in this brochure was A. and N. Music Company, which sold sheet music and musical accessories at 4708 Montgomery Road.

Norwood celebrates its heritage every summer by hosting Norwood Day. In this picture, Coletta Lammert and Todd Hunter pose for the camera. Both Lammert and Hunter were chairmen of Norwood Day at the time this picture was taken, around 1970.

Virginia Todd and Jerry Green, shown in this picture, were also cochairmen of Norwood Day around 1970. Norwood Day has been held at Kings Island (in 1973) and at Lesourdsville before settling on old Coney Island, where it is held presently.

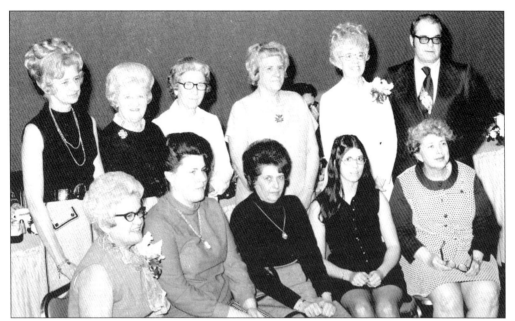

This picture of the Norwood Business Women's Association was taken during the year that Dolly Toler passed on her reign as president of the group to Mary Kuebler. The women in the picture are, from left to right, (first row) Mary Kuebler, Helen Armstrong, Bobie Groves, Esther Mahan, and Charlotte Schockley; (second row) Mary Kuhn, Viola Henjes, Ruth Kriege, Marjorie Sponsel, Dolly Toler (now Lyons), and Mayor Joseph Shea Jr.

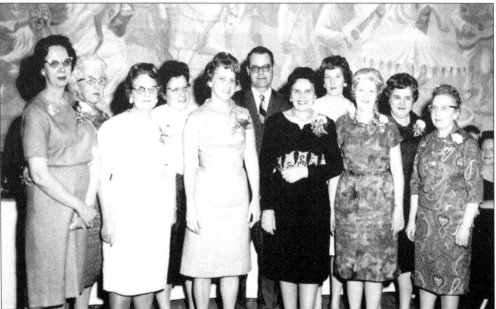

This 1965 Norwood Business Women's Association picture shows the induction of new members. Coletta Lammert, who worked at the First National Bank, was the incoming president. Dorothy Hutchison, the outgoing president, stands on far left of the picture. The other women are, from left to right, Opal Miller, Leola Mullins, Billie Naberhaus, Jeanette Forester, Ruby Insko, Viola Henjes, Sylvia Walters, and an unknown woman. Mayor Joseph Shea stands in the center.

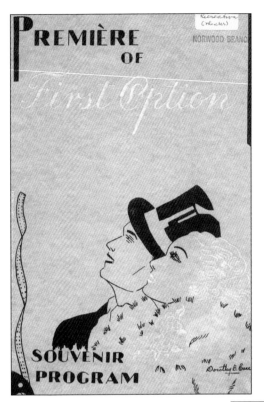

This brochure advertises the Cine Club's first movie, titled *First Option*. The plot follows Samuel Adams, his daughter Nancy, and her sweetheart, Joe Martin. Martin and Adams Sr. invent a new type of gasoline, and the movie's antagonists, Phillip Norton and his father, try to buy the first option on the new invention for an unfair price. Adams and Martin win out, and Martin and Nancy live happily ever after.

Margaret Radcliffe was the "directoress" of the Cincinnati Cine Club. This club formed in January 1935 at 205 Vine Street, Cincinnati, to learn about producing amateur motion pictures. The club solicited movie scripts from members and chose one to produce. The movie was made in and around Cincinnati, and the club premiered the movie in the city. Monthly membership dues cost $1 per month, plus a $10 initiation fee.

This is a brochure for a play put on by the Norwood Republican Club in 1938. Officers for the year were Joseph G. Gusweiler, Clifford Boden, Paul Lutz, and Ralph Schubert. This show was in its 20th year at this time. The Norwood Women's Republican Club was founded in October 1927, and the Norwood Women's Democratic Club held its first meeting in November 1933 at the home of Violette Trauth.

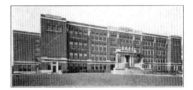

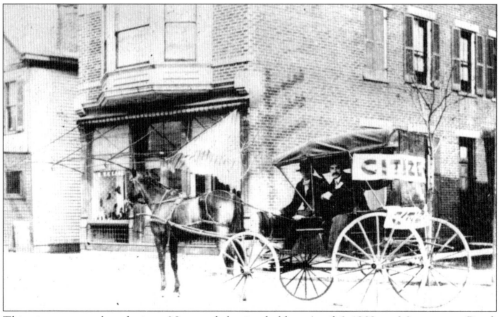

This picture was taken during a Norwood election held on April 6, 1903, on Montgomery Road. Early on, however, Norwood had some money troubles. On December 14, 1882, only $275.95 was reported to be in the town's budget. Some Norwood residents donated money to the fund, including L. C. Black, who donated $150, Col. Philander Parmele Lane, who donated $300, and Edward Mills, who donated $100.

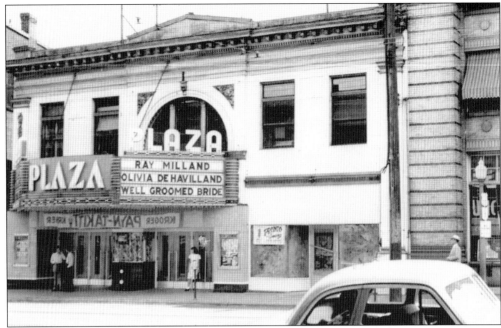

This picture of the Plaza movie theater was taken around 1947. The building was built around 1911 at 4630 Montgomery Road. Norwood had two other neighboring movie theaters, including the Ohio and the Norwood. The Twin Drive-In, also in Norwood, was the first drive-in movie theater in the area.

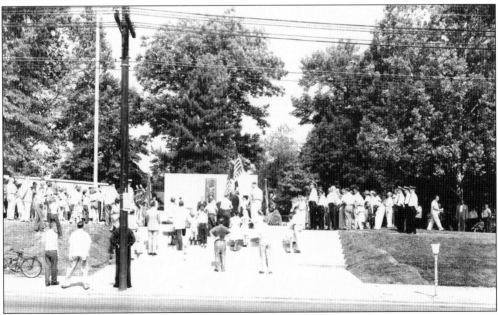

This picture was taken at a dedication of the War Memorial in Victory Park. The Norwood Service Men's Boosters, including chairman Harold Ihlendorf, organized the development and building of the monument. The American Legion Post No. 123 also helped. Harry M. Nelson designed the monument, which was dedicated on Armistice Day in 1942. In 1975, the park sponsored winter, spring, summer, and fall tournaments, as well as other special programs.

Five

DAILY JOBS

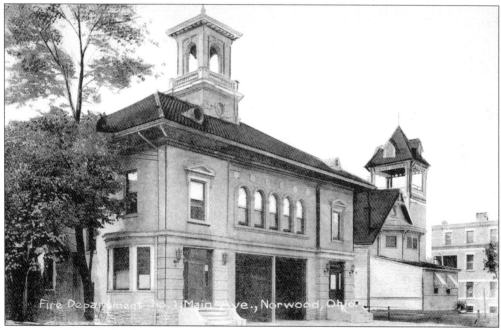

Norwood's first official fire department was formed in 1890 in response to a major fire that destroyed Peter J. Schneider's home at 1702 Sherman Avenue on Sunday morning, March 9. The next day, a group of concerned citizens met, and the West Norwood Volunteer Fire Brigade was soon founded. Many of the volunteers were St. Elizabeth church members. Volunteers helped construct the original building, which was built entirely in one day: July 4, 1890. Land was purchased on Mills Avenue, west of Franklin Avenue, and the Dexter Lumber Company donated lumber. The wives of the fire volunteers, along with other neighborly ladies, cooked for the builders. When construction was finished, a dance was held, and an elegant silk banner was given to the volunteers. This picture shows the first firehouse built on Montgomery Road.

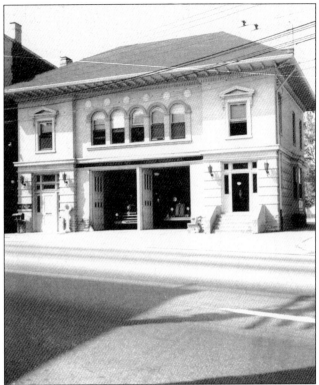

This picture shows a more up-to-date firehouse. The company's first firehouse burned down on the eve of the 1894 elections. A candidate had passed out free cigars to encourage the firemen to vote for him, and the cigars were discarded in a wooden box filled with sawdust. The men went home, and the smoldering cigars managed to burn down the entire firehouse and destroy all the equipment.

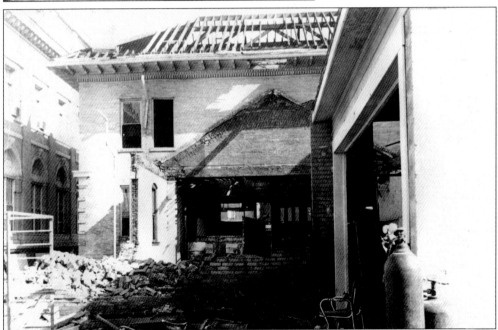

Norwood's No. 1 Volunteer Fire Brigade was organized on January 23, 1892, with 35 members and went through a series of firehouses. Around 1974, for instance, the group's firehouse was torn down, as seen by this picture. This firehouse stood next to city hall, right near the present-day Heritage Park, on the opposite side of their present-day location, as seen by the previous picture.

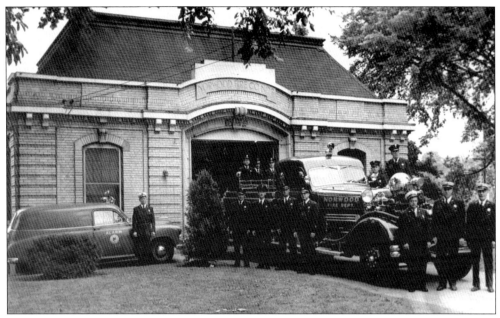

This is a picture from around the 1940s or 1950s of the Norwood Fire Department Company No. 3. The men stand outside the house that was built near the present-day Shea Stadium. On the ground, from left to right, stand Bob Lampert, Bob Parr, Fred Roelter, Fred Benz, Greens Felder, Chief Tom Fisher Jr., and Theodore Parr. On the truck, from left to right, are D. Gabriel, Harold Long, Larry Bond, Paul Hock, and Fred Benz. The gentleman on the far left is unidentified

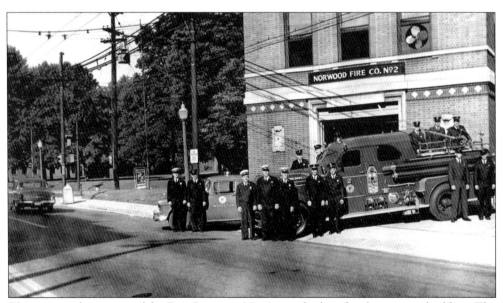

This picture shows men of the Fire Company No. 2 outside their fire department building. The men standing on the left side of the picture are two inspectors, and the men in the white hats are probably captains at Fire Company No. 2. This picture was taken around 1940.

This picture shows the firehouse on Ivanhoe and Montgomery Roads for Fire Company No. 2. The house for Fire Company No. 3 was built at Harris and Lloyd Roads. Company No. 3 opened in 1913, right in front of Shea Stadium on Harris Avenue. Men lived on the left; the right side had a sitting room, office, television, and kitchen in back on the right. The pool was on the left. The company had one pumper (fire truck) with three men working on it. During World War II, the building was a rationing depot, and it closed afterward in February 1987. Around 2000, the school board purchased the firehouse, which was demolished, and a new entrance was built to Shea Stadium. Company No. 2 merged with Company No. 1, and the two departments operate out of the present-day house on Montgomery Road. In 2006, there is only one operating firehouse and department, which is the Firehouse Company No. 1, based at Montgomery Road.

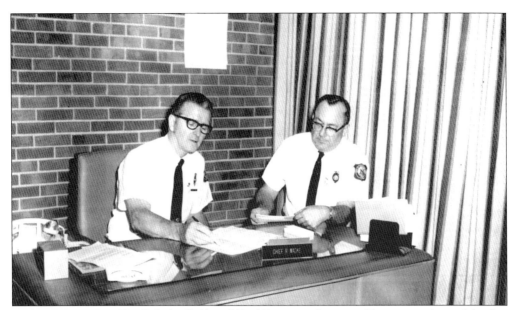

In this picture, Fire Chief Macke (left) and Fred Bentz can be seen. Charter members of the first Norwood fire department include B. W. Ahlers, Cornelius F. Buckley, Clemens Buddelmeier, L. H. Gebhart, William Greiwe, John W. Hall, F. Koehler, Joseph Koehne, Joseph Lammers, Joseph Lamping, F. J. Meister, William C. Nathman, Henry Rikoff, John Rolsen, Frank Runnebaum, Lester W. Schierberg, Peter J. Schneider, Gustave Schmidt, J. H. Schulte, Theodore Lowman, Charles S. Weisenfelder, and Charles H. Woertz.

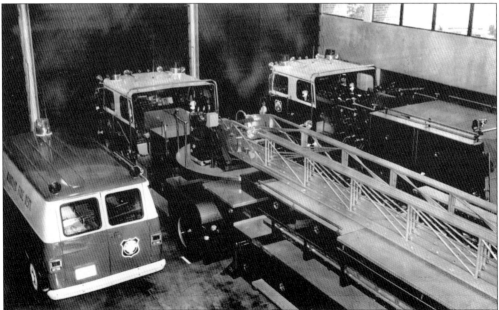

This picture shows three trucks inside the present-day fire station at Montgomery Road. In August 1905, the Company No. 1 firehouse moved from Smith Road to the south side of city hall, at the intersection of Montgomery Road and Elm Avenue. This was the home of Norwood's first paid fire department. The men in this unit included Joseph A. Geller, James J. Moriarity, Charles H. Woertz, and Frank Huelsman.

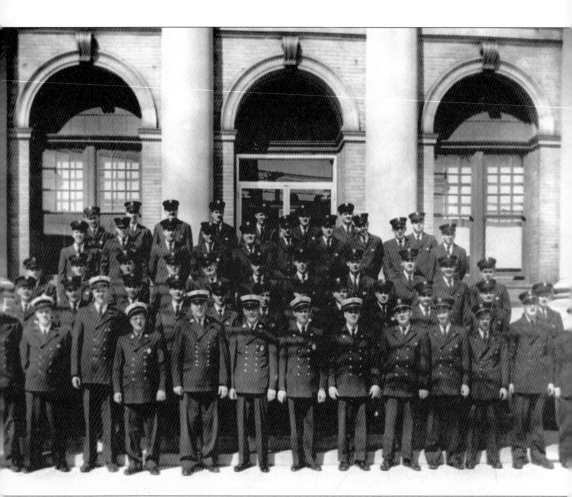

In this picture stand a few members of the Norwood Fire Department. Standing from left to right are (first row) Fred Roller, Dave Talmadge, Russell Woertz, Dave Greensfelder, Tom Fisher, Ted Parr, Harold Glaser, Al Bientz, Fred Benz, Jack Brinkers, Lou Chuskman, Dick Macke, and James Doherty; (second row) ? Ernspeger, ? Hammond, Lee Fenske, John Alexander, John McCauly, Harry Brown, Paul Bond, George Lambert, Bill Kirschner, Harold Long, Ron Morgan, and Larry Bond; (third row) Jack Brown, Dee Gabriel, C. Huelsman, E. Sylvester, C. White, A. Abbutiells, Fred Schwankhaus, Paul Hock, Bob Parr, Leon Hughes, and Gary Cooper; (fourth row) Ray Hessel, Rus Ramsey, unidentified, Bob Lampert, Earl Dockum, unidentified, Dick Heideman, Ed Imm, Jerry Clements, and Tim McCabe; (fifth row) Les Gresham, unidentified, William Hammann, Jem Fischer, Lou Wilms, Denny Christian, John Laage, and Bill Patrofbe.

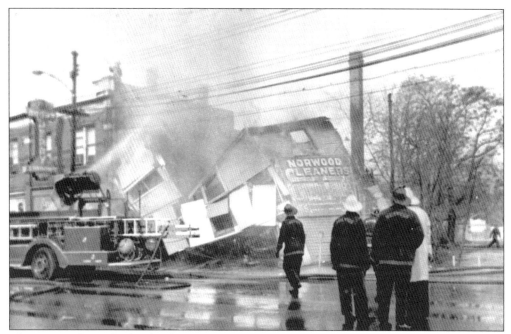

This picture shows the fire that happened at the Norwood Cleaners. This site gave way to Quality Hotel and Suites at 4747 Montgomery Road. In 2006, the firehouse stands at 4725 Montgomery Road, down the street from Norwood City Hall and next to the police station. In 2006, there are 58 firefighters in Norwood.

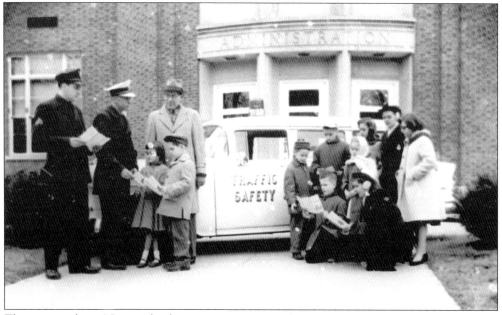

This picture shows Norwood policemen giving away safety certificates to children. In the 1930s, six special school traffic officers were trained. This department was instituted because of the swelling population in the Norwood School District. Men continued to watch over the safety of these heavily crowded crosswalks, and women joined the team in 1952. Some older students from local schools assisted in the operation.

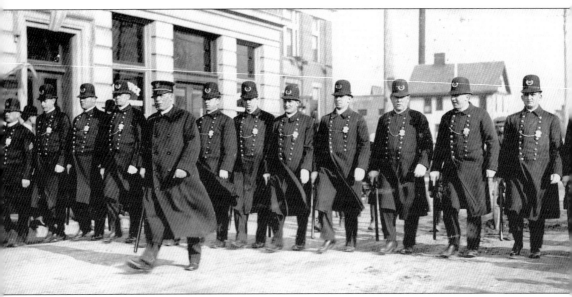

This picture shows the Norwood police walking down the street in the early 1900s or late 1800s. The first appearance of order in the small Norwood municipality was Gerald Kehoe, who was the town marshal. In 1903, with a soaring population of 6,480, the department bought two bicycles, in addition to the two mounted police officers and one horse-drawn patrol already in service. In 1910, the number of police officers had increased to 22. Equipment used at this time included an electric wagon plus the two bicycles and one horse-drawn patrol. It was not until 1920 that a motor-driven cruiser was used in fighting Norwood crime.

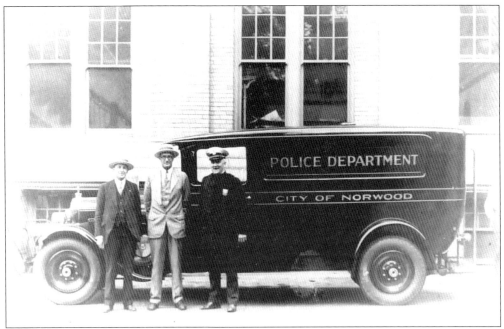

This picture shows an early example of what a Norwood police cart looked like. Throughout the years, the Norwood police have continually been improving their strategies used to catch criminals. A Bureau of Criminal Investigation was established in 1921, under the direction of Edward J. Lee. And in 1939, more than 40,000 fingerprint records were on file.

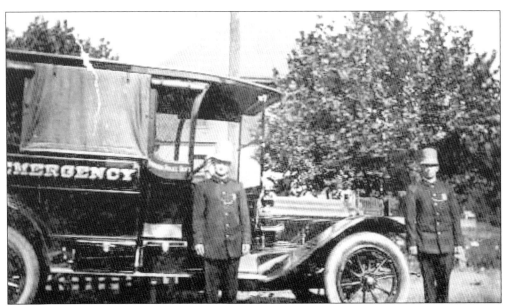

This is a later picture of a police paddy wagon. By 1930, the 27-member police unit used two motorized cruisers and a motorcycle to patrol the streets of Norwood. By this time, all cars and motorcycles were equipped with short-wave radio receivers. A police training center was built in 1958 on Park Avenue, east of the Salvation Army building. The structure was dedicated to R. Edward Tepe, a past Norwood mayor.

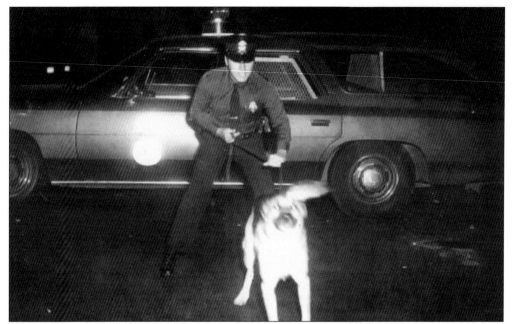

This picture shows Officer Tom Williams Sr. with Duke. The first canine police unit was instituted by Chief Harry Schlie in 1971 and included Williams and Duke, along with Officer Paul Cain and Trooper. Duke retired in 1977, Trooper in 1978. The K-9 unit was disbanded until February 2000, when Officer Joseph Dipietrantonio and Axel became the second-generation Norwood canine unit. In 2006, Tom Williams is mayor of Norwood.

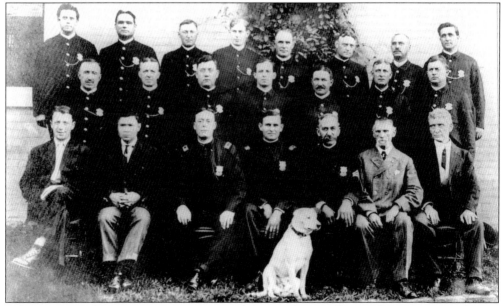

Policemen pose for a picture in 1910. From left to right are (first row) Louis Supe, Thomas Brothers, Oscar Wiley, Thomas Worth, Henry Sloan, William Long, and Clem Ahlers; (second row) John Mahoney, George Grim, Andy Hart, Harry Eppens, Henry Piepmeyer, Walter Hobb, and an unknown man; (third row) Edward Green, Edward Tracy, Lt. Harry Kent, Chief Carl R. Wenzel, Sgt. John Grismere, and three unknown men.

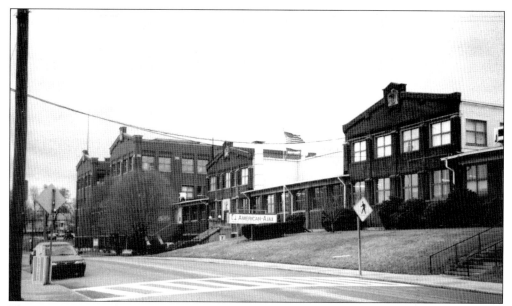

This is a picture of the American-Ajax building, the structure in which the American Laundry Company was housed. One very popular Norwood business in 2006 is the Aglamesis Brothers Ice Cream and Candy shop. Opened by Thomas and Nicholas Aglamesis in 1908 at 9889 Montgomery Road, the store was originally called the Metropolitan. A second store was opened in Oakley at 3046 Madison Road in 1913. During the Depression, the brothers sold their name to a friend and renamed their shop Aglamesis Brothers.

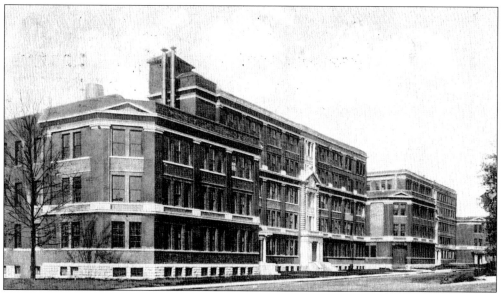

The Globe-Wernicke Company was incorporated in 1882 as the Globe Files Company. The business originally sold office equipment, but the name changed to the Globe Company in March 1887 and later changed to the Globe-Wernicke Company. The business invented the vertical file in 1898; however, the U.S. Patent Office would not give them a patent for the item. The company now operates as Cardinal Brands, Incorporated.

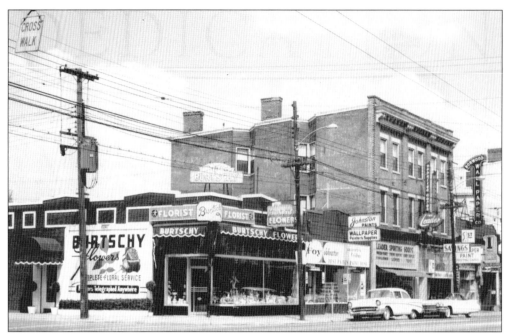

This is a picture of Burtschy florists, owned by Jewel Burtschy and her husband. Another Norwood staple was Ben's Jewelry Store, owned by Rose and Ben Youkilis. Ben was instrumental in encouraging the Norwood Chamber of Commerce to produce the Norwood history book *The City of Norwood, Ohio*, which came out in 1957.

Theodore Dorl and Paul Fern opened the Dorl and Fern floral shop on October 1, 1938, at 3803 Montgomery Road. They moved to 3805 Montgomery Road in February 1939, then to 4400 Montgomery Road. Dorl graduated from Norwood High School and the University of Cincinnati. He was also very active in the community. Dorl married Edith L. Bittman, and the couple had two children, Theodore E. and Susan L.

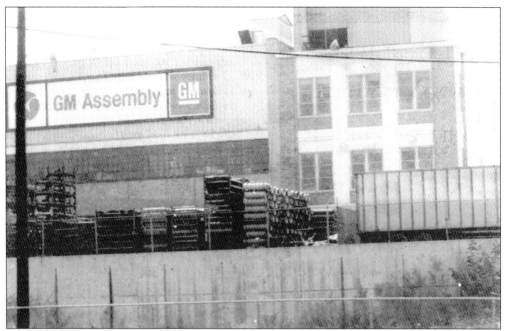

The beginning of General Motors Car Company is in the Fisher Body Company, which started in July 1908 in Detroit. The Fisher brothers—Fred and Charles—started the company with just $50,000. Brothers Alfred, Edward, Lawrence, and William joined the company later. In 1923, the Fisher Body Company moved to Norwood at 4726 Smith Road.

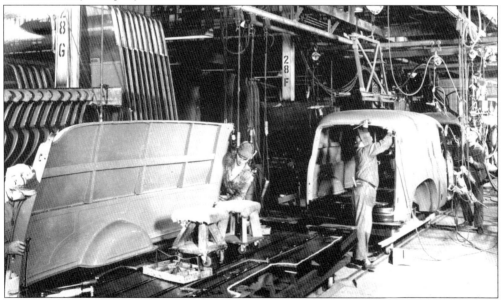

This picture shows the Norwood General Motors Assembly Division. Fisher Body was an automobile body engineering company that designed, fabricated, and assembled cars for the General Motors Company. James E. Goodman started working at the Fisher Body plant in Norwood, and by the late 1950s, Goodman was working as the General Motors vice president and general manager. In October 1986, General Motors announced that it was closing, eliminating more than 4,000 jobs. The demolition of the plant started on August 26, 1987.

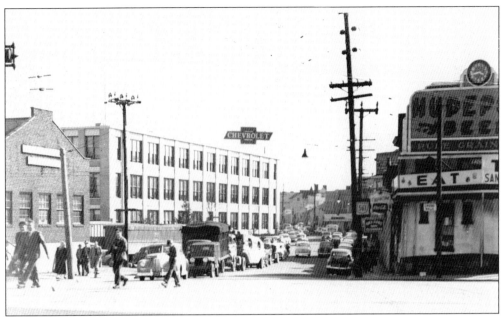

The Chevrolet plant moved into the Norwood area in 1923. At that time, 300 employees worked there, most of which were day laborers who were paid 40¢ an hour. They produced one model: a crank-starter, four-door sedan. The plant was built on an old ballpark and half-mile track that originally belonged to Joseph Langdon. The circus also used this old field; the company would unload its animals from the nearby railroad.

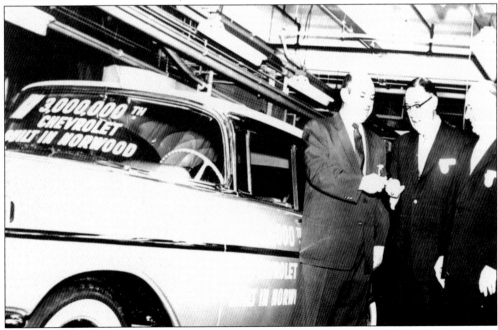

This picture of the three-millionth Chevrolet car built in Norwood was taken in 1956. In the 1950s, this division of General Motors served 700 dealers in southern Ohio and paid an annual average amount of $10.6 million for wages and supplies in the Norwood area. The first shipment in 1923 equaled 40 cars, which were personally driven to dealers in the tristate area.

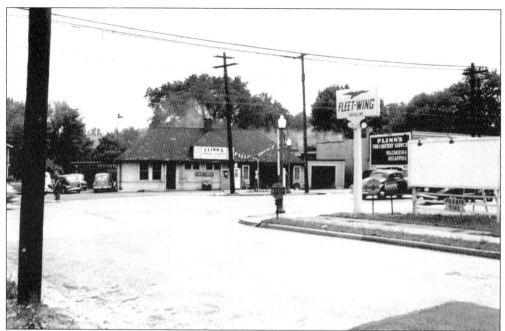

This picture shows the Flinn's Tire and Battery store, at Montgomery Road south of Ashland and Wanda Avenues. Before this company moved in, the building was a commuter station for the Cincinnati, Lebanon and Northern Railroad. The station's name was Hopkins Avenue Station and operated as such from 1885 to the late 1920s.

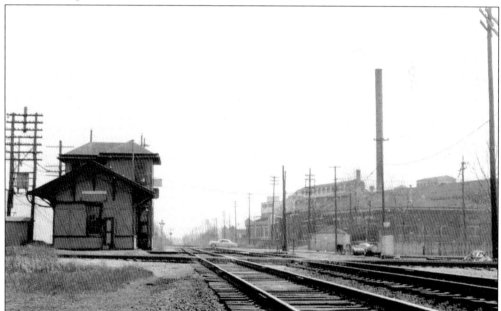

George Bullock started building the Bullock Electric Company plant in 1897 near Forest and Park Avenues, right by the Baltimore and Ohio railroad tracks. Residents were nervous that Bullock would build an ugly factory building, so the company countered these fears by building a brick plant with trailing vines and a divider along Park Avenue. This served as a buffer between industry buildings and residential homes. The plant opened in 1898.

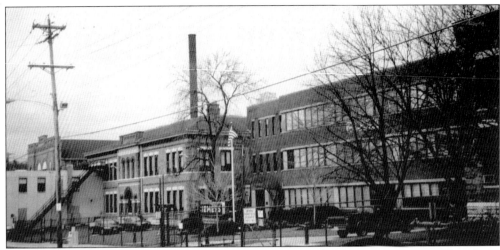

In 1904, the Allis-Chalmers Company bought the Bullock Electric Company. This shows the three-building Norwood plant, at which 300 employees worked. During both world wars, the Norwood plant produced several motors, including some for the Manhattan Project. The company also donated time and money to local cooperative programs. In the 1970s, the plant grew to an 18-building complex and employed more than 1,000 employees. In 2006, the company is now the Siemens Company.

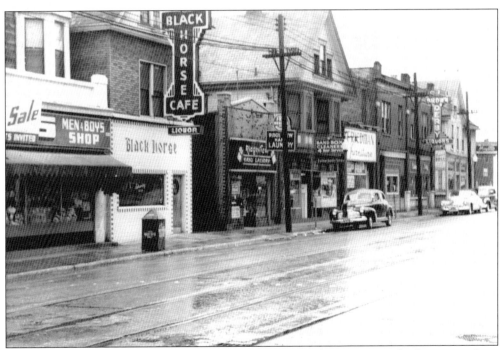

This scenic picture shows the Black Horse Café, Brown Derby Liquors, and other stores along Montgomery Road. Other area stores included Max's clothing shop, which was at the north end of Montgomery Road but later moved to Swifton Shopping Center. Sherman Avenue Tailors was also a popular spot to go for clothes and clothing alterations. Freddy Zorndorf owned the shop.

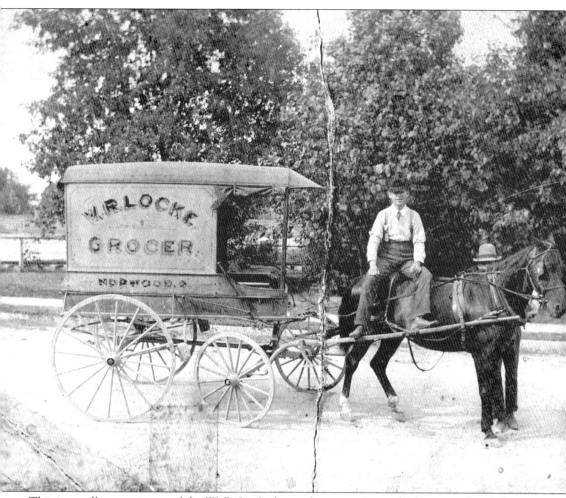

This is a well-worn picture of the W. R. Locke horse-drawn carriage, which was used to deliver groceries from the Locke grocery. Another early company was started by T. J. McFarlan, who opened a lumber outlet in Norwood in 1883. McFarlan spent his free time as the captain of the Norwood Volunteer Fire Department, at which time there were 11 volunteer firemen. McFarlan was the president and general manager in the early decades of the 1900s, right around the time the company's name changed to Dexter Lumber. The Dexter company won first prize in the 1931 Clean Yard Contest. The event was sponsored by the Ohio Association of Retail Lumber Dealers and awarded businesses that kept their company site clean and organized. T. J. passed away in 1942, and his son A. L. took the reigns of the company. In 1957, William Clements was the vice president, and Louise Schleicher was the secretary-treasurer.

This is a picture of the Albers grocery store. Albers stood on the west side of Montgomery Road, near the former site of the Crew Concrete and Building Supply Company. All these former buildings have been razed to make room for the Surry Square Shopping Center.

Judge Allen C. Roudebush was Norwood's mayor from 1934 to 1937 and again from 1940 to 1943. Roudebush attended Batavia High School, Denison University, and Harvard University. While at Denison, he won nine intercollegiate athletic letters and later played professional baseball. He married Lillian in 1912 and served as a citizens chairman in the NSL in 1933 and 1935.

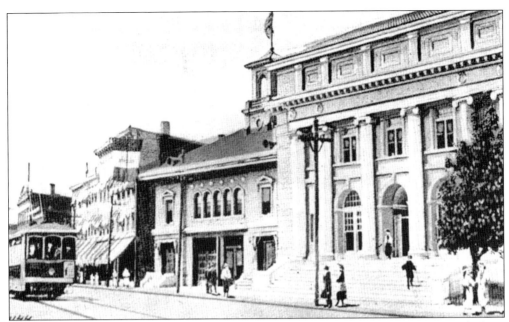

Norwood City Hall was originally built in 1915. This picture was taken from Main Avenue, looking south down the street. The early-20th century mayors of Norwood were George E. Mills (1901–1905), Charles H. Jones (1906–1909), Orville F. Dwyer (1910–1911), William M. Fridman (1912–1913), Harry E. Englehardt (1914–1919), Louis H. Nolte (1920–1925), and Harry H. Baker (1926–1933).

George Hafer, a mayor in nearby Avondale, donated the site for the hall. The children of Hafer, in turn, donated a fountain to the neighboring park as a family memorial. The first five mayors of Norwood were John Weyer (1890–1891), Aaron McNeil (1892–1894), Judge David Davis (1894–1897), Dr. T. V. Fitzpatrick (1896–1898), and Charles E. Prior (1899–1900).

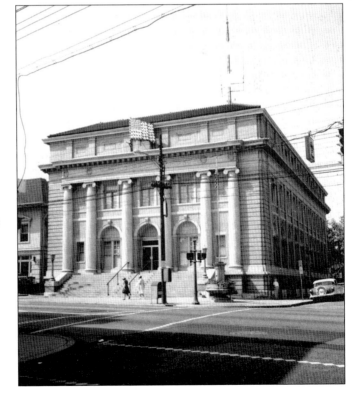

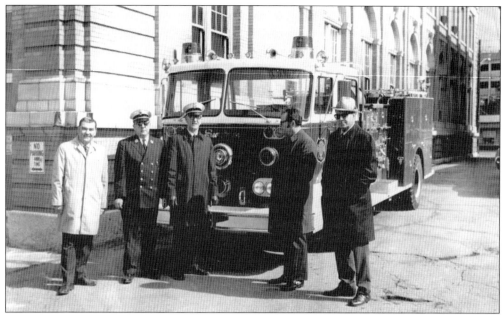

Standing from left to right are Safety Service director Tom Walker, Fred Benz, Chief Macke, Mayor Joseph Shea Jr., and Ray Tepe. Tepe's brother, R. Edward "Ed" Tepe, served five terms as mayor of Norwood from 1947 to 1957. Ed married Dorothy Geiger on May 29, 1937, and had six children: Edward Jr., Mary Beth, Thomas, Stephen, David, and Martha Ann. Ed's political mission was to crack down on gambling, but he was killed in a deadly car crash in June 1957.

This picture shows part of the Heekin Can Company, started by James Heekin. Heekin's son James J. ran the company from 1903 to 1928. James J.'s brother Albert E. presided from 1928 to 1948, and a third brother, Dan M., was president from 1948 to 1954. Dan's nephew, Albert E. Heekin Jr., took over in 1954. The Norwood plant opened in 1915 at Park and Forest Avenues. The company grew from 75 to 265 employees.

The American Laundry Machine Company was founded in 1868 by A. M. Dolph and J. H. Slack. The pair started their fledgling business by making washers on Home Street in Cincinnati. While it is unclear what the original name was, it is known that the company changed names to the A. M. Dolph Company in 1884 before changing again in 1893 to the American Laundry Machine Company. The first plant on Pearl Street burned down in 1901, so a two-story factory was built in 1902 on a five-acre lot at Ross and Section Avenues. The company merged with five other laundry machinery manufacturers in 1907 and led the industry. In 1915, the company was the first to introduce the all-metal washer. It prospered so much that in 1925 a modern, concrete plant was added to the original building. A mural of the company originally appeared in the Union Terminal in Cincinnati in 1933. In 1956, they bought the Speedy Washer Company and, in 1960, became a division of the McGraw-Edison Company.

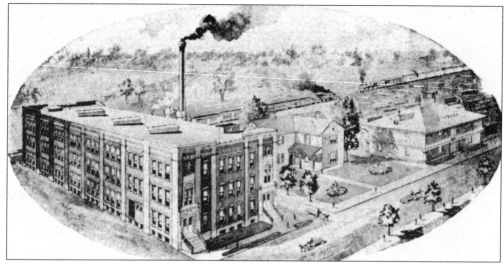

This picture shows the Boss Company in Norwood. Other important Norwood businesses include the Norwood Recreation Billiards (Benny's), U.S. Shoe Corporation, Queen Optical, Ben's Jewelry Store, Sherwin-Williams Paint Store, White Castle Restaurant, F. W. Woolworth, Neisner Brothers Variety Store, Bob's Lock and Key, Foley's, Antone's Shoe Repair, B. F. Goodrich, Quick Service Dry Cleaners, Merle Norman Cosmetics, and Midwest Music.

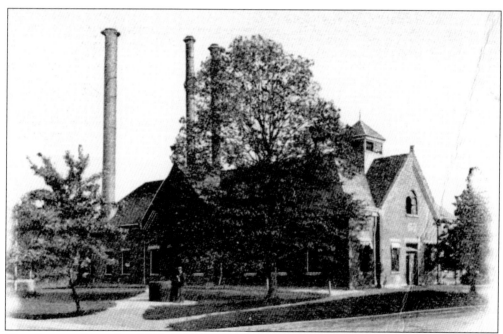

This drawing shows the old Norwood Water Works Pumping Station on Harris Avenue. The village engineer in 1889, who may have helped work the pumping station, was D. A. Hosbrook. Other members on this early board of councilmen included Fred H. Mehmert, Edward Mills, William Leser, J. P. Zimmerman Sr., D. H. Whitehead, Anthony Weiand, Philip Moessinger, T. J. McFarlan, Robert Thompson, and A. H. Pape.

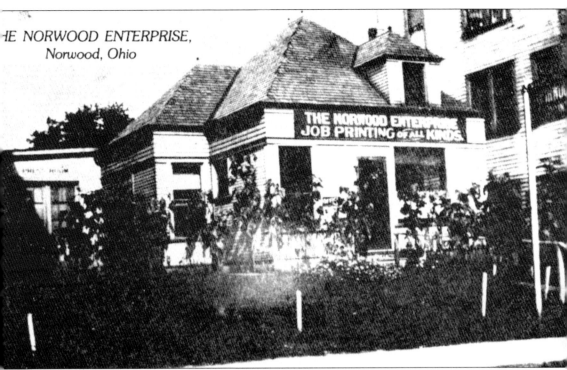

THE NORWOOD ENTERPRISE,
Norwood, Ohio

The *Norwood Enterprise* was published by Richard "Dick" Moore. Moore started as a publisher for a weekly newspaper in Walnut Hills, then he started the *Enterprise* in 1894. He sold the newspaper to Sanford Klein and Kirk Schockley in 1905, and Klein later sold his shares to David Tarbell. In 1922, the newspaper had a circulation of 2,000 subscribers. Tarbell and Schockley sold the newspaper to Dale Wolf in that same year, and the Wolf Publishing Company was created in 1927. By 1940, there were four weekly newspapers; the *Norwood News*, *Norwood Enterprise*, and the *Enterprise* were all owned by the Wolf Publishing Company. The *Norwood Herald* was the fourth newspaper being published at this time. Dale and his wife, Ruth, had six children, including Harriet "Hap" Arnold. Ruth was secretly the author of the "Father of Norwood" column, an editorial-type article that ran in the *Norwood Enterprise*. The Wolf family ran the paper for 62 years.

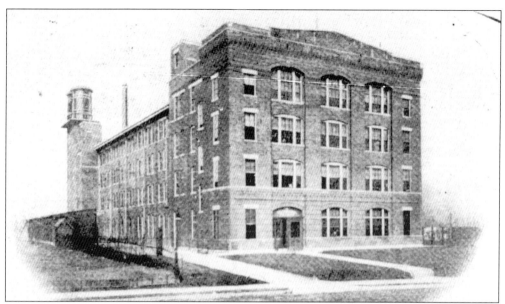

The Strobridge Lithographing Company became a Norwood-based company in 1937, after it moved from Central Parkway. In 1855, the company operated as the Middleton and Wallace firm and then changed names to Strobridge Lithographing Company in 1881. The company printed posters for circus, theater, vaudeville, and minstrel groups. Located at Montgomery Road and Surrey Square, it achieved great success between 1867 and 1900. The company was bought in 1961 and closed in 1971.

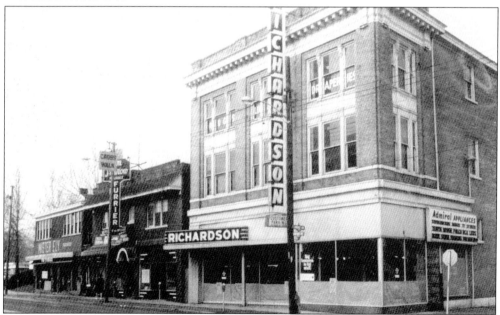

The Richardson store, at Lawrence Avenue and Montgomery Road, sold furniture. This building was formerly Floto's Department Store—a popular clothing store. Henry Floto opened the first store at 4269 Montgomery Road and later moved down the street to 4529 Montgomery Road. Henry's son Carl ran the business solo from 1923 until 1941, when he partnered with W. J. Schlie. Carl died on July 2, 1956, and Schlie took full control.

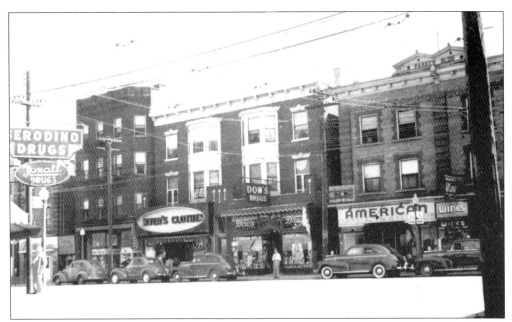

In this picture of Montgomery Road, one can see the Myer's clothing shop. Myer Friedman moved from Washington, D.C., to Norwood in 1929 and opened this store at 4610 Montgomery Road. Friedman was a member and director of the Norwood Business Men's Club and a member of both the Mason and Shriner organizations. He married Sara Kondritzer, and the couple had three daughters: Audrey, Joan, and Peggy.

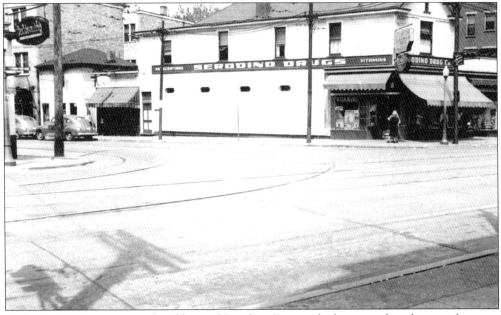

In this picture, one can see the old site of Serodino Drugs, which operated in this area for many years and was an especially hot spot during the 1950s. This picture was taken at the northwest corner of Sherman Avenue. Later, Serodino moved across Montgomery Road, near the present-day Walgreens at 4600 Montgomery Road. Serodino's had a soda fountain in the store, making it a popular hangout for teenagers.

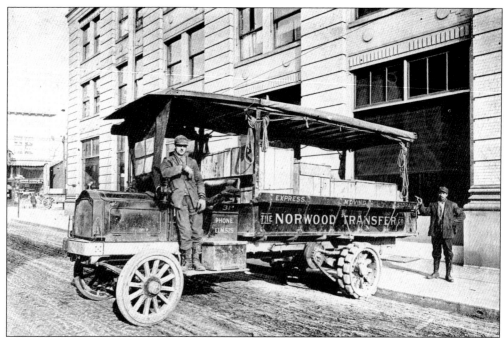

This picture shows Norwood's early inclination toward public transportation. Bill Hanon is credited with starting the first Norwood line, his competition being the Cincinnati Motor Bus Company and the Norwood Bus Company. The latter first introduced open-top, double-deck buses but was later bought by the Blue Bus Company. Bus fare in the World War II era was 15¢ or two rides for 25¢.

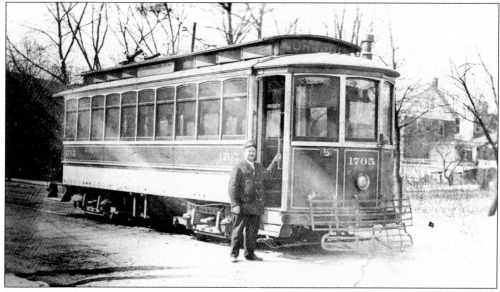

This picture shows one of Norwood's early streetcars. There used to be six streetcar lines that ran through Norwood: Route 9, Old No. 8, South Norwood, Route 7, Route 5, and Route 4. In the early 1950s, streetcars were replaced by trolley buses, which were later replaced by diesel buses. Harry Kuhlman owned the first bus line that ran through the area, but he later sold to Captain Carr.

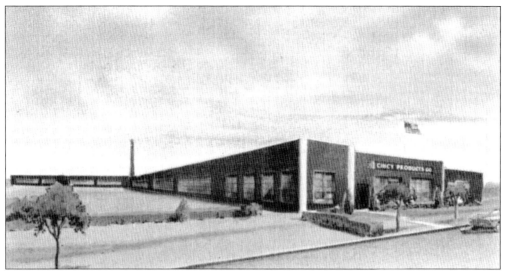

This sketch shows the Cincy Products Company, which later became the Norwood Wall Paper Company. The company specialized in paper hanging, paper cleaning, and greeting cards and decorations. The building sat on Robertson Avenue in neighboring Oakley. In later years, this company produced quite an unusual product: Play-Doh. More modern-day companies include Stone Bowling Lanes and the Ohio Woodworking Company.

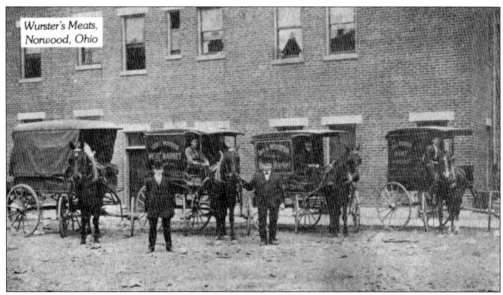

Walter C. Wurster and his brother, George L., opened Wurster's meat market on Montgomery Road in 1906. Walter married Elizabeth Ann Heller that same year. The couple started out living in an apartment above the store. The brothers' father, Johan Georg (George) Wurster, emigrated from Germany and operated his own meat market in Camp Washington, Cincinnati.

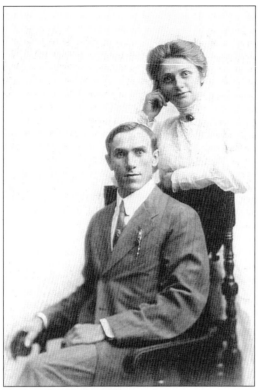

This is a picture of Walter and Elizabeth Wurster. Wurster's sold meat, fish, poultry, and rabbit for the popular German dish hausenpfeffer. The couple's children remember the many meals they enjoyed because of their father's business, including sweetbreads, calves' liver, and veal stew. One employee, Irwin Frisch's brother, David, went on to start the local Frisch's Big Boy franchise.

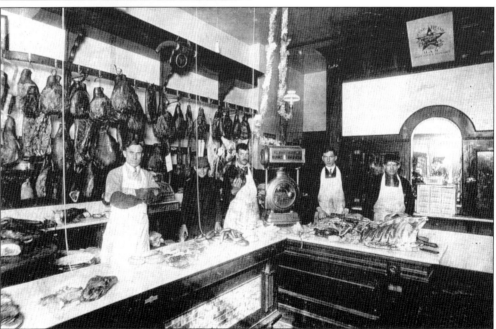

This picture shows the inside of Wurster's. Meat markets outgrew their popularity in the 1950s and 1960s as larger grocery stores included meat departments. In 1969, Wurster's Meats was sold to George Kersker, who ran the store until 1985. That year, the entire block was demolished in the push for urban renewal.

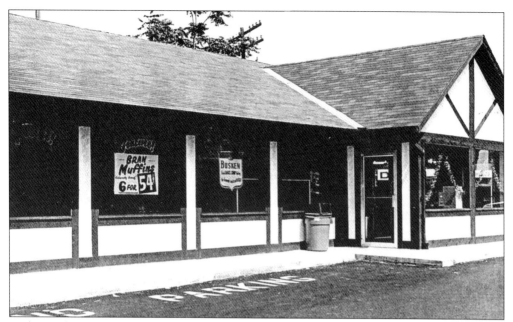

Busken Bakery started when Clem G. Busken opened a bake shop in Oklahoma City in 1919. His son, Joe, came to Cincinnati to help an uncle in the cigar box trade. He soon tired of that profession and, in July 1928, opened his bake shop on Erie Avenue in Hyde Park. He opened a second store in Pleasant Ridge in 1929, and this Norwood shop on Montgomery Road opened in 1932.

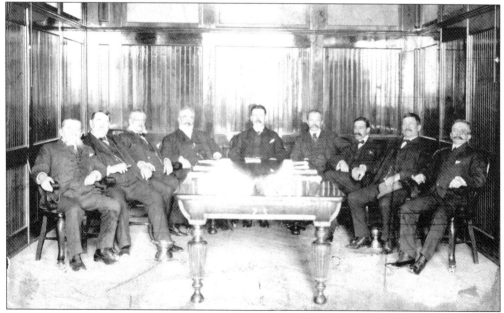

This group of men was all executives of the United States Playing Card Company (USPC). The company got its start in January 1867, when four men—James M. Armstrong, Robert J. Morgan, John F. Robinson Jr., and A. O. Russell—bought the *Cincinnati Enquirer*'s "Enquirer Job Printing Rooms." Their offices were located at 20 College Street, downtown Cincinnati, and the business was called Russell, Morgan and Company.

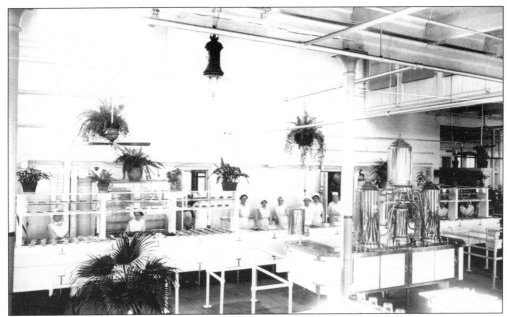

The kitchen facilities at USPC were divided into two different sections: male and female. Even today, two sets of identical staircases run throughout the building, built so that men and women working at the plant would not fraternize with each other. During World War II, the company sewed parachutes, produced decks with pictures of enemy armaments for soldiers to study, and manufactured secret maps into cards sent to prisoners.

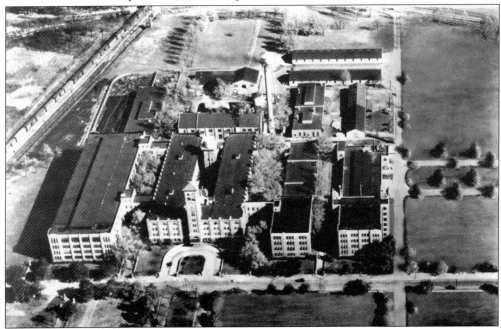

This early aerial shot of USPC shows how large the factory and card shop really is. It is interesting to note the lack of development around the area, including no houses along the highways. At its peak, the company produced 2,200 different kinds of cards. In 2006, a museum inside the factory displays a wide variety of playing cards and memorabilia.

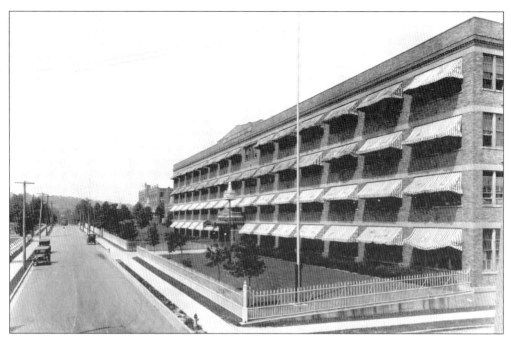

In this shot of the USPC, one can see a variety of tall birdhouses. These houses were kept on the property to ward off bugs. The USPC moved to its present-day Norwood location in 1900. The company owned 30 acres, 600,000 square feet of which was regulated for manufacturing. In 2006, the birdhouses no longer exist, but the USPC is still in business.

Norwood residents can always spot the USPC square, brick clock tower. Built in 1926, the tower is four stories high. The tower also allowed radio broadcasting for station WSAI from 1922 to 1930. The station was then sold to the Crosley Radio Corporation. In the early days, the USPC printed theatrical and circus posters. On June 28, 1881, the company printed its first deck of playing cards.

In November 1872, the company moved from College Street to Race Street in search of larger manufacturing space. In 1880, the company expanded, adding two additional stories to meet the needs of its newly started card printing plant. The company name changed in 1891 to the United States Printing Company, and by 1894, the United States Playing Card Company became a separate company to accommodate all the orders.

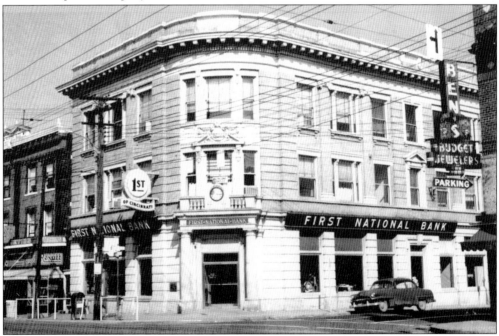

This picture shows the Norwood office of the First National Bank of Cincinnati. This bank originated as the First National Bank of Norwood. The bank opened in 1902, and by January 1903, a plot of land on the corner of Washington Avenue and Montgomery Road was bought from Benjamin F. Smith. This building was completed in 1907 and was remodeled in 1908 and 1921.

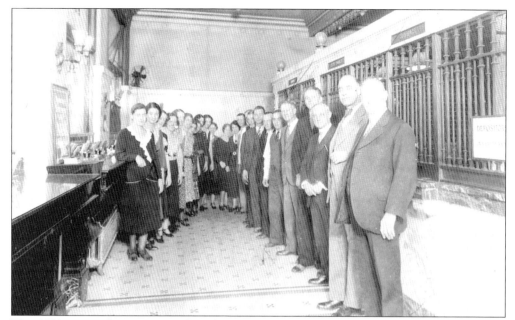

This 1932 picture shows a group of employees welcoming newcomers to the First National Bank. Thomas McEvilley opened the First National Bank of Norwood in July 1902. O. H. L. Wernicke was elected the bank's first president, and McEvilley was the cashier. McEvilley became bank president in 1933 and remained in that position at least until March 1952, when the bank merged with the First National Bank of Cincinnati.

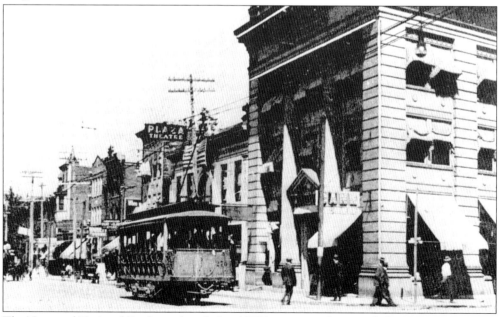

The Norwood National Bank was founded in 1907 by a group of men including Myers Y. Cooper, Edward Mills, Louis E. Ziegle, Dr. J. C. Cadwallader, John O. Omwake, Charles Kilgour, and Frank Kinney. Cooper became the president of the Norwood National Bank in 1908. He later become chairman of the Norwood Hyde Park Bank and Trust Company board in 1957 and then eventually worked as the governor of Ohio.

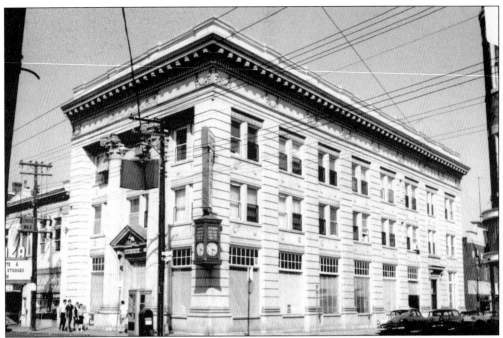

The Hyde Park Bank merged with the Norwood National Bank in 1929, creating the Norwood Hyde Park Bank and Trust Company. Edward Mills was instrumental in building the Norwood Town Hall and the Hopkins Avenue railway station. Later the station was converted to the Flinn Gas Station. In 1957, this bank had more than 15,000 accounts, making it the largest bank at the time in Hamilton County.

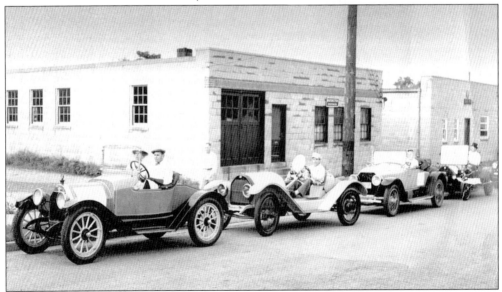

The Zimmerman company building is pictured on the far right, next to the Wilfert Electric building. Charles H. Zimmerman started the Zimmerman company in 1920 with his wife, Vesta. In 1946, the company moved to its present address at 2768 Highland Avenue. Charles passed the company to his son, Ralph Colette Zimmerman, who passed it to his son Ralph Charles "Chuck" Zimmerman. Chuck's daughter Marilyn Bell is now in charge of most of the day-to-day operations.

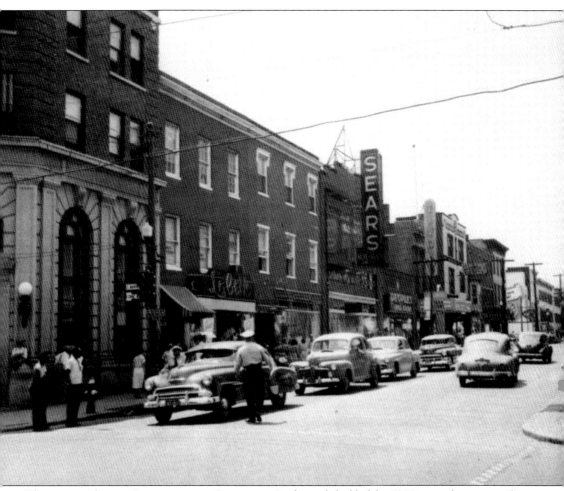

This picture shows a Cincinnati-area Sears store. In the early half of the 1900s, people nationwide could order precut, ready-to-assemble houses from Sears. While the kits did not include masonry materials, they did include shingles, windows, doors, floors, nails, and paint. Customers could choose from more than 100 styles. From 1909 to 1937, Sears sold almost 100,000 of these types of houses, some of which cost less than $1,000. In 1918, the most expensive house in the Sears catalog was $5,140. The Norwood Sash and Door Manufacturing Company on Section Avenue near Ross Avenue was bought by Sears in 1912 to help produce these prefabricated houses. Sears sold the plant to the employees in 1945, and the Sash and Door Company continued to produce ready-made homes and garages. The company is still in business, as the Norcor Sash and Door Company, and is located at 4953 Section Avenue.

This picture shows the United Dairy Farmers float in 2000 for the company's 60th anniversary. Carl H. Lindner initiated the idea for such a company in 1938, during a time when most milk was still delivered house-to-house. He and his wife, Clara, had four children, each of whom worked in the family business: Carl Jr., Robert, Richard, and daughter Dorothy Kreuzman. The first store opened on May 8, 1940, at 3955 Montgomery Road, where the present-day headquarters still stands. The store sold cheaper milk products—milk, butter, cottage cheese, and eggs—which made housewives happy but not the dairy delivery men. The first day's business brought $8 in profit, but two local dairymen harassed Carl H. afterward. Nevertheless, the store continued to thrive, and subsequent stores were opened in Norwood, Silverton, and St. Bernard, in that order. In 2006, the United Dairy Farmers owns more than 200 stores throughout the tristate area of Ohio, Kentucky, and Indiana.

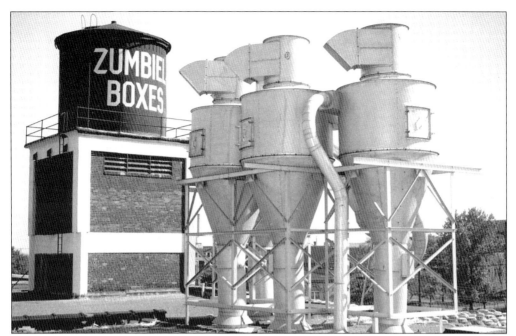

This close-up shows the Zumbiel name painted on the roof of the company's plant in Norwood. In 1974, the company was 125 years old. The company originated when Charles W. Zumbiel bought the Daniel B. Jordan Company from Jordan's widow in 1876. Zumbiel had been an employee at the company, which was located at Fifth and Main Streets in downtown Cincinnati.

In 1940, the company needed to expand, and the business moved to the old Boss Washing Machine Company in Norwood. Zumbiel's son, also named Charles, took over the company when the elder Zumbiel died in 1916. The younger Zumbiel was just 19 years old. This picture shows George Michaels, a man who took the younger Zumbiel under his wing and taught him everything he needed to know about business.

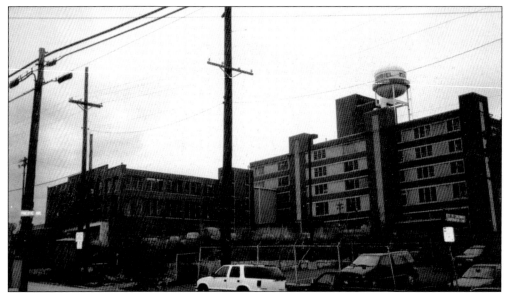

Robert Zumbiel is the current president of Zumbiel. Charles W. Zumbiel, the founder, had six children: Charles W., Robert G., Richard A., Thomas Jerome, Catherine, and Nora. Richard, Catherine, and Nora never married, and the three lived together in a house until their deaths. The next generation of children who worked at Zumbiel include two of Robert G.'s sons—R. W. and Thomas James—and David, the son of Thomas Jerome. Now the fourth generation works here, including Michael W. and Edward A., the sons of Robert W. Thomas J., the son of Thomas James, also works there currently.

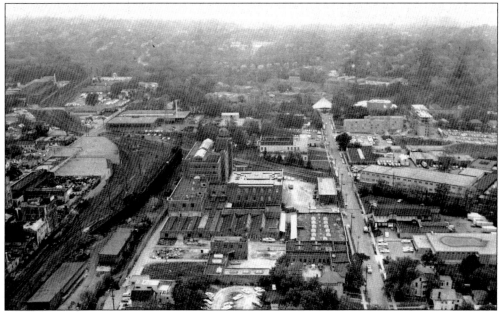

This picture shows the Zumbiel building on Cleneay Avenue. The building was used for bottle carriers and storage. Other Zumbiels involved in the company in 1974 were Richard A. Zumbiel, the vice president, and Thomas J. Zumbiel, the treasurer. In 1973, the company building on Harris Avenue expanded, adding 75,000 square feet, seven additional truck docks, and several million dollars of new equipment.

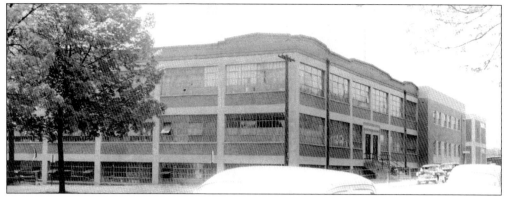

This picture shows the Zumbiel plant on Harris Avenue before an addition was built. In 1974, there were 400 employees and two plants, one on Harris Avenue and one on Cleneay. Another local company was the Cincinnati Tool Company. Frank Martin founded this company in 1879, with offices at Pearl Street. The company moved to a building in Norwood at 1951 Waverly Avenue in 1900.

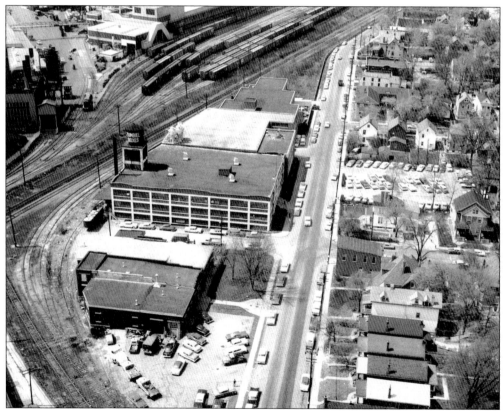

This picture shows the offices at 2339 Harris Avenue. The company hosts an annual family picnic to hand out "Length of Service" awards. In 2006, the company has a reputation for being a family organization and retaining employees for many years. In 2006, the company has relocated its offices to Hebron, Kentucky. (Thanks to Dolly Lyons, who has been with Zumbiel 52 years, for these pictures.)

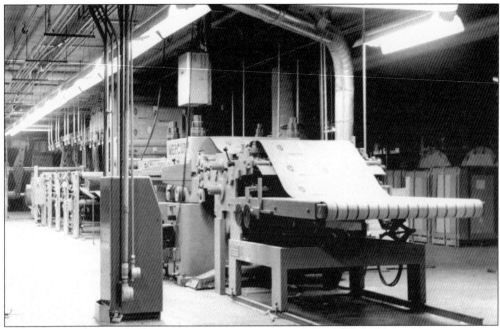

Here one can see the press shop at Zumbiel. In 1988, the Zumbiel company celebrated 145 years of operation. Robert W. Zumbiel was the president at the time, and Thomas J. Zumbiel was the vice president. The two were grand marshals at the Norwood Day parade in 1988. The company is the oldest manufacturer of boxes in the Greater Cincinnati area.

---GO TO---
Drs. Schwartz Brothers
Painless Dentists

1612 Main Street CINCINNATI, OHIO

Because they give you the very best professional service;
Because they have no hired help and attend to you personally;
Because they do as they promise and promise no impossibilities;
Because they use only sterilized instruments which guarantee cleanliness;
Because they tell you exactly how much your Dental Work will cost you before they undertake it;
Because their Price is as low as possible for good Dentistry.

Set of Teeth................$3.00 and Upward
A Better Set for...........$5.00 and Upward
Gold Crowns................$3.00 and Upward
Natural Color Crowns...$3.00 and Upward
Bridgework (per Tooth)..$2.00 and Upward
Porcelain Fillings........$1.00 and Upward
Gold Filling................$1.00 and Upward
Silver Filling..............50 cents any Size

No Charge for Extracting where new Teeth or Bridgework are Ordered

Painless Treatment is our Specialty.
GAS ADMINISTERED IF DESIRED.

Drs. Schwartz Brothers, Painless Dentists,
1612 Main St., near Liberty St.
ESTABLISHED 1894 PHONE CONNECTIONS
OFFICE HOURS 8 A. M. to 8 P. M.

This advertisement showcases the Schwartz Brothers' dentist shop. Another famous Schwartz is Richard B. Schwartz, who talks about many popular Norwood hangouts in his book, *The Biggest City in America: A Fifties Boyhood in Ohio*. Schwartz lived with his family at 1421 Ryland Avenue until moving to 5604 Fenwick Avenue, where the family lived from 1950 to 1960.

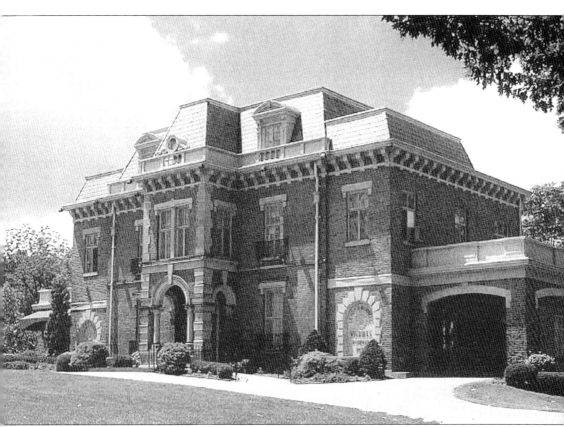

This picture shows the Vorhis funeral home at 5501 Montgomery Road. The Norwood branch of the funeral home opened in 1933, but the history goes back to the late 1800s. The house was built in 1867, and Col. Philander Parmele Lane lived here. Jacob Vorhis first established a funeral home in Sharonville, Ohio, in 1876, and the company moved to Lockland, Ohio, in 1888. Jacob died in 1897, and his son Albert M. took over. Albert M.'s son Frank helped out with the business, as well as Leroy J. Russell, a World War I veteran who started working at the home in 1919. In 1924, Russell became a partner at Vorhis when Albert M. retired. There are two other Vorhis funeral homes, one at 310 Dunn Street in Lockland and one at 10365 Springdale Pike in Springdale.

This picture shows Rookwood Pavilion, a large outdoor shopping mall that opened in 1993. One of the shops in this area is Joseph-Beth Booksellers, which opened in December 1993. The owners are Neil and Mary Beth Van Uum. Restaurants in Rookwood include Buffalo Wild Wings, Bucca di Beppo, and Don Pablos, which is in the old LeBlond factory building.

R. K. LeBlond started the LeBlond Company in 1887. In its early years, the company manufactured tools for type making, including gauges and printing molds. LeBlond expanded into a machine-tool making plant in 1891. The company opened on Pearl Street, then moved to the Linwood area. In 1918, the LeBlond Company moved to the corner of Madison and Edwards Roads.

Six
NOTABLE SIGHTS

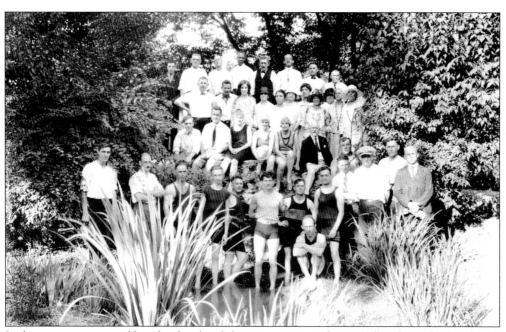

In this picture, a group of friends take a break from swimming at the McCullough pond. The Charles McCullough Estate housed the McCullough Seed Company, which started in 1938. The company sold seeds collected on this 48-acre farm. This photograph was taken in 1926 at the McCullough Seed Company picnic. Today the farm is only six acres. The estate house was built in 1848. Charles McCullough's sons have also built other homes in the surrounding area. Many of these pictures were donated by Albert Blackburn, the great-grandson of James Morrison McCullough. The Lindner Park McCullough Nature Preserve was dedicated on September 14, 1985. Mayor Joseph Sanker gave the welcoming address and recited the proclamation at the dedication. Ann McCullough and family attended, as well as both Richard D. and Carl H. Lindner. During the late 1980s, John and Mary Wiseman helped grow the herb garden on park grounds.

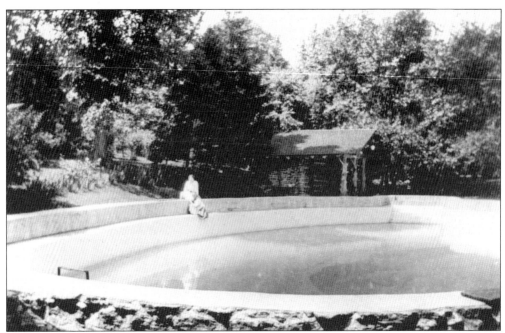

This pool, on the McCullough property, is rumored to be the first one of its kind in the area. It and the bathhouse were constructed around 1910. The two people in the photograph are unidentified. Robert and Bess Strong, cousins of the McCullough family, lived in this house for many years until they sold it to John Mullane, owner of Mullane Candies.

This picture, taken in the 1900s, shows a group dressed up for Thanksgiving on the McCullough property. In 1986, the McCullough property was turned into a park and named Lindner Park. It was given as a gift to the city from Ann McCullough's granddaughter Marjorie McCullough Hiatt. Bentley Meisner Associates, Incorporated designed and installed the formal rose garden. Ann's original rose garden has been turned into an herb garden.

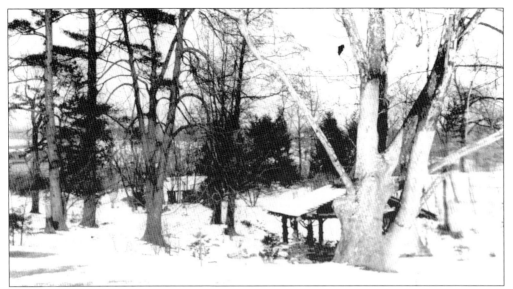

This photograph shows the original springhouse on the McCullough property. In this picture, one can barely make out the pool's bathhouse in the background. This picture was taken in 1920. The large sycamore tree by the springhouse still stands in 2006. The arbor and fence posts are built from western red cedars. In later years, Jim Truesdale and members of the Youth Corps kept up the landscaping and trails in the summer.

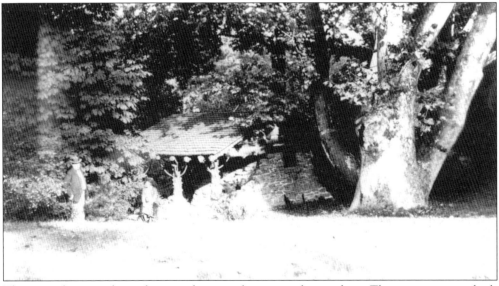

This second picture shows the springhouse with more modern updates. The structure was rebuilt around 1910. The man and woman are unidentified. Charles McCullough's friend John Hall worked for a time as the Lindner Park caretaker. Community volunteers have also pitched in from time to time, including the Norwood Business Women's Association and members of the Norwood Senior Center.

This picture shows what the original McCullough estate looked like in 1875. This was before Cyprus Way, the street on which present-day citizens can access the house, was built. The house stood on 160 acres of land bought between 1802 to 1830.

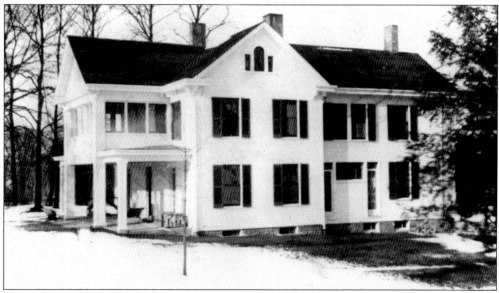

This picture shows the remodeled McCullough homestead. The house was fixed up around 1920. Albert McCullough's house is on the hill in the distance. John Mullane, of Mullane Candies, bought the house right around the time this picture was taken. Trimble and Ann McCullough later purchased the house to keep the building in the family name. Ann and Trimble successfully grew many different varieties of vegetables.

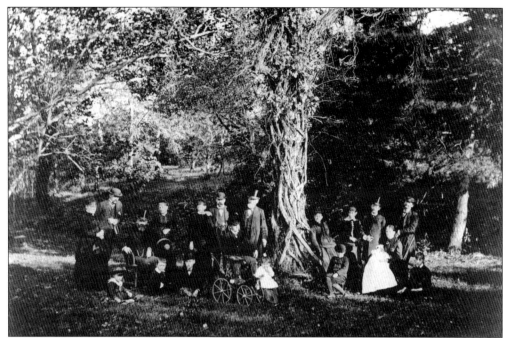

In this picture, taken around 1880, Albert and his wife, Josephine, stand on the far left. James Morrison McCullough, the original homestead owner, is standing next to the tree. Jane McCullough Drake (holding a baby) can be found on the right side of the tree. Other people in the photograph are unknown. Some early Norwood pioneer families included Mills, Smith, Langdon, Williams, Durrell, and Drake.

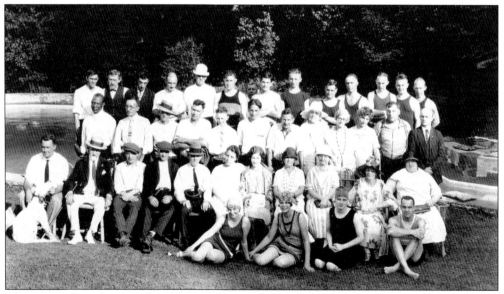

This is another photograph taken in 1926 at the McCullough Seed Company picnic. The yearly get-together was held on the McCullough estate grounds. The men in the photograph are the only ones identified. The two men sitting in the first row, on the far left, are J. Charles McCullough, the president of McCullough Seed Company, and Dwight Brown Sr., the vice president and treasurer of the company.

This early picture shows a good view of Norwood's Indian Mound between 1880 and 1900. However, many residents were at first opposed to building a water tower. Instead, they argued that water continue to be pumped from surrounding artesian wells. Dr. G. Springer argued that a water tower be built for two reasons: the pumps were in danger of breaking down eventually, and a tower would give an adequate supply of water to the growing town.

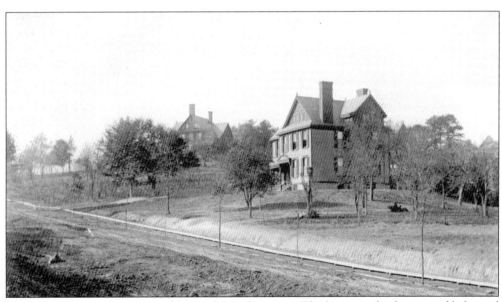

This picture shows the origins of Indian Mound Avenue. The house in the foreground belonged to J. Charles McCullough, and Albert McCullough's house is on the hill. The entrance of the avenue was at the present-day address of 5333 Indian Mound. The Indian mound is nearby Norwood's water tower.

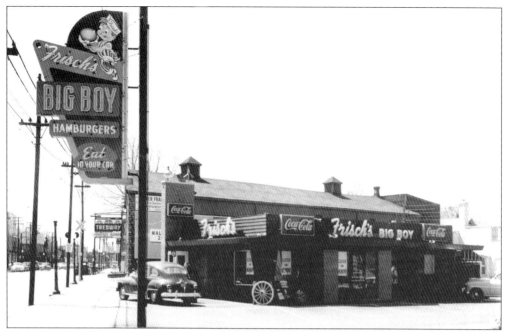

Dave Frisch, a Cincinnati native, started the Frisch's Big Boy restaurant chain. In 2006, this restaurant can be found at 4765 Montgomery Road in Norwood, although there are more than 40 restaurants throughout Cincinnati and northern Kentucky. The restaurant's signature sandwich is the Big Boy, a double-decker hamburger with tartar sauce.

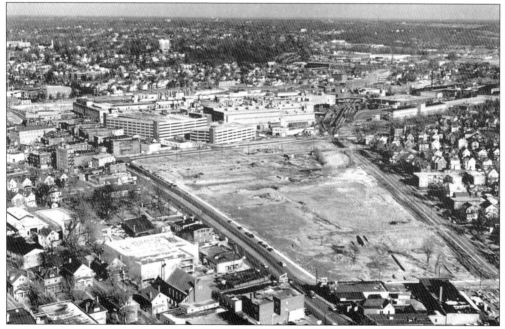

This picture is an aerial shot of the center of Norwood taken on January 17, 1972. The large land tract is to be Surrey Square. At the bottom left corner, one can see the Norwood Library. The main street on the left is Montgomery Road, and Lafayette Road is the main street on the right. The General Motors plant sat in the center top section of this picture.

To entice prospective buyers during the early 1880s, realtors often promised a free trip to Norwood from Cincinnati on one of the city's many trains. The General Motors plant sat on the left of these tracks, and the Zumbiel company sat in front of them until 2006. Forest Avenue now runs under these tracks.

In this picture, one can see the Baltimore and Ohio (B&O) railroad tracks near the Zumbiel company. The B&O railroad station was once the main passenger station on the B&O route, which stopped at the Cincinnati Union Terminal. At one time, there were six railroads within Norwood's limits, plus two—Harewood and Norwood Heights—that boarded the city to the north. The station was abandoned in the 1950s.

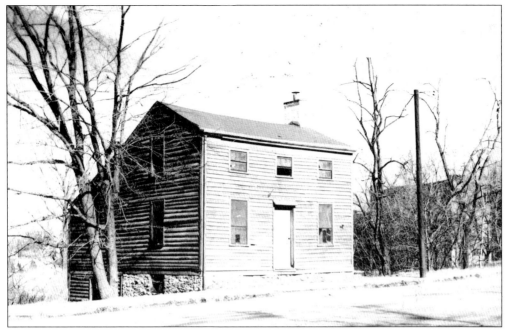

This is a picture of an old house built in 1864 during the Civil War. The house was at 5243 Montgomery Road but was demolished in 1950. One early resident, Lewis C. Hopkins, was credited with building an early subdivision in the area. On June 13, 1888, he sold lots for $600 to $700. It was he who pushed to turn Norwood into an incorporated village.

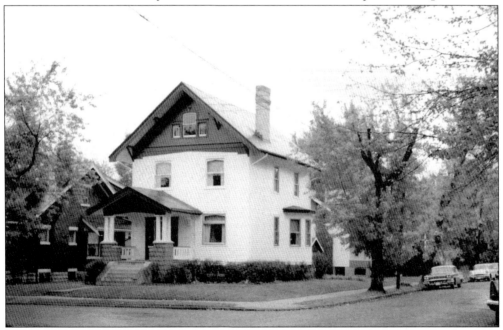

This is a picture of a house at 2501 Marsh Avenue. Here lived Mrs. G. Lyle Ringland and her family. Ringland's mother, Jessie Warman Wilson, donated the work titled "Indian Treaties" to the Norwood Library. Wilson received the document from her relative E. E. Brownell of Dayton, Ohio. Brownell was a descendant of Benjamin Franklin's teacher, George Brownell.

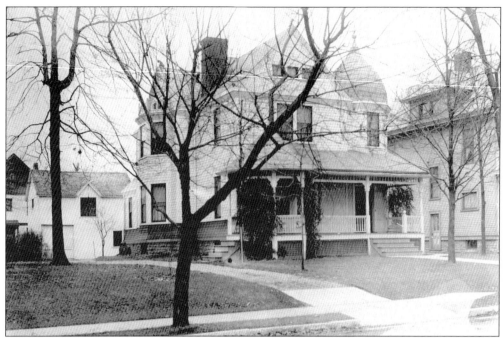

This is a picture of a house at 2242 Cameron Avenue. In the early years of the 1900s, the Collins family lived here. Mr. Collins was a railroad worker and wrote a book on the subject. He and his wife had a child named Elsie. The house was later sold to a pastor at the Grace United Methodist Church. In 1978, Robert and Pamela Rigling, with their two children Kevin and Keith, bought the house.

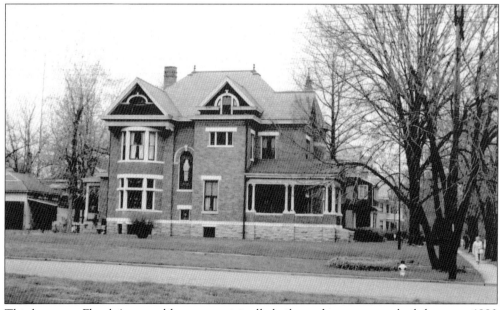

This house on Floral Avenue, like many originally built on the street, was built between 1880 and 1900 for the upper-middle-class people in the area. The style of the house is Queen Anne, and it includes towers, tall chimneys, turrets, and plenty of porch space. There is also a well-kept stained-glass window that one can see in the center of the picture.

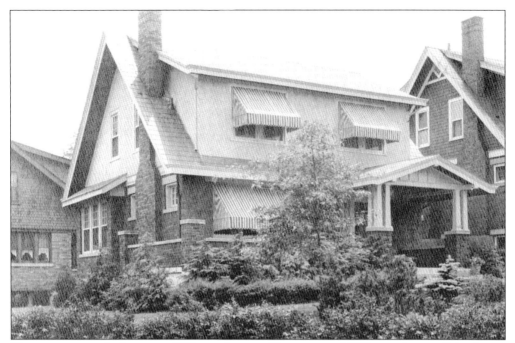

This is a picture of a house on Williams Avenue. The street and Williams Avenue School were named after the Williams family. The family bought their 213-acre property from Symmes Grant for 66 2/3¢ an acre. Sometime between 1867 and 1870, the owners built a home adjacent to the first one for other family members.

This unusual building sits at the corner of Montgomery Road and Slane Avenue. There is a lot of unique architecture in Norwood. One such house belonged to "Holy Joe" Wilberding, an eccentric sculptor. This house sat somewhere in the 1700 block of Mills Avenue and boasted many small rooms and a large amount of unusual stairways. Because of its artistic distinctiveness, neighbors nicknamed the house "Michaelangelo's Angel House."

This triangular building sits on the corner of Carthage Avenue and Montgomery Road. It was originally built as a bank. Supposedly, the first house in Norwood was built near the present-day Grace United Methodist Church. The house was built in 1800 and was occupied until around 1895. At that time, there were three main thoroughfares—Montgomery, Williams, and Duck Creek.

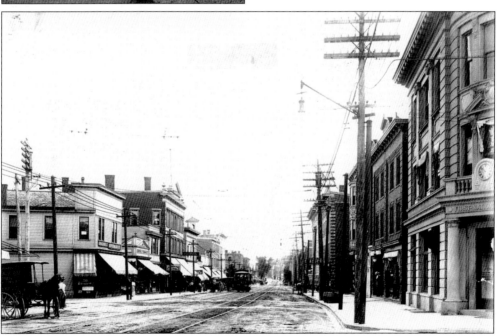

This early picture is of Montgomery Road. Norwood was home to quite a few tollgate roads, including ones at Cincinnati, Montgomery, Hopkinsville, and Clarksville Roads. One tollgate sat outside the old Drake farm, but a fire in 1859 destroyed the structure. A replacement gate was rebuilt at the corner of Smith and Montgomery Roads, where the Sanker's Beer Garden restaurant sat.

This is a picture of Samuel Hannaford. Born on April 10, 1835, in England, Hannaford immigrated to the Cincinnati area. He became a well-known and well-respected architect and is most known in this area for building the Music Hall in downtown Cincinnati. Hannaford's great-nephew, Francis, was a longtime Norwood citizen and amateur historian. It is because of Francis's early photographs that a lot is known about this area.

This is a picture of the Norwood flag. A letter sent to the "Honorable Board of County Commissioners of Hamilton County," filed on March 5, 1888, was the first record of Norwood's incorporation. In 1940, Judge Oliver G. Bailey sent a letter describing the transition of Norwood the village to Norwood the city.

This picture shows Fenwick Park on Fenwick Avenue in Norwood. Another local hot spot for recreation is the Richard E. Lindner Family YMCA. The building is on the corner of Sherman Avenue and Walter Road, across from Norwood High School. Three other parks in nearby communities include Crest Hills, an upscale Jewish country club, Losantiville Country Club, and Maketewah, a gentile club in a Jewish neighborhood near Bond Hill.

Mayor Joseph Shea Jr. throws out the first pitch in a Little League softball game. This game is taking place at the old National Waterparks Park. There are nine parks in the area, including Fenwick, Hunter, Marsh, Millcrest, Northwoods, and Williams. Dorl Field is also home to many recreational games. The parks annually host swim and track meets, as well as talent shows, picnics, and playground championships.

This picture shows the Waterworks park. Norwood has always had good luck with water, especially because of the four artesian wells that originally dotted Norwood. In 1937, a huge flood ransacked the city of Cincinnati, and these wells provided pure drinking water to many inhabitants in and around Norwood. The wells were capped in 1957 because they were too expensive to maintain. A well next to the police academy at Park and Linden Avenues was reactivated in 1977.

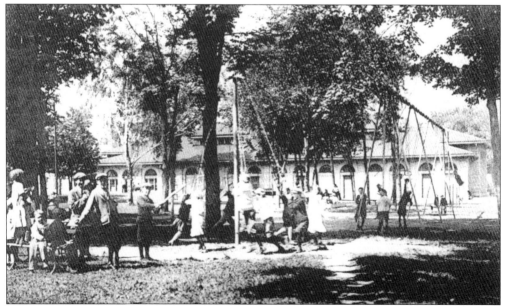

This picture shows children playing at one of Norwood's many public parks, most likely Victory Park. Another early outdoor recreation spot was the Strobel family farm at 2352 Harper Avenue. In 1890, Norwood residents urged that the farm be converted into a park, since the area was so beautiful and serene. Local artists came to the farm to paint and sketch the area. The farm was also a breeding ground for racing and trotting horses.

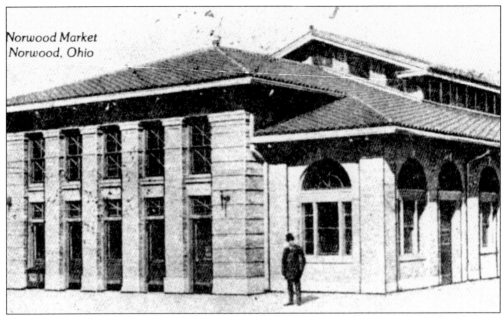

This is an earlier postcard of the Norwood Safety Lane. The building was originally a farmers market but has been used for many other purposes over the years. In the first half of the 1900s, Protestant churches held summer evening church services here. Different church congregations took turns conducting the services. Part of the area is now home to Victory Park. Henry W. Kahle was instrumental in developing this area.

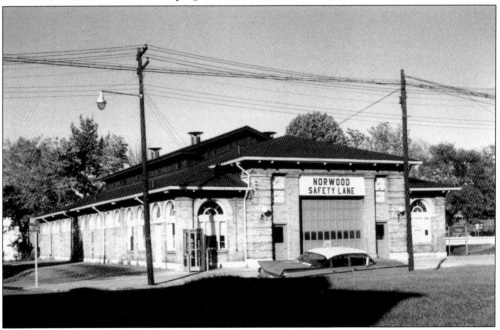

The building morphed into the Norwood Safety Lane in 1940 and stayed that way for many years. The license bureau operated in the front of the building for a longer period of time. Mayor Donald Prues was mayor of Norwood at this time. Before that, the building was a skating rink and also housed bathrooms for users of the Victory Park swimming pool.

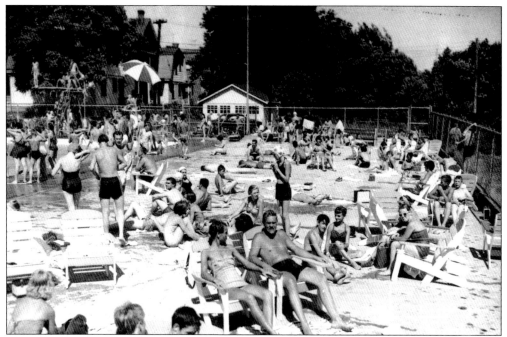

This is a picture of the Norwood Municipal Swimming Pool. The hours of operation were 10:00 a.m. to 10:00 p.m. daily. John B. Wirth was the executive director of the Norwood Recreation Commission for about 13 years. Gordon E. Brown was director in the 1970s. During his tenure, Shea Stadium was built, as well as one running track, tennis and basketball courts, the John B. Wirth Memorial Pool, and a recreation center at 2605 Harris Avenue.

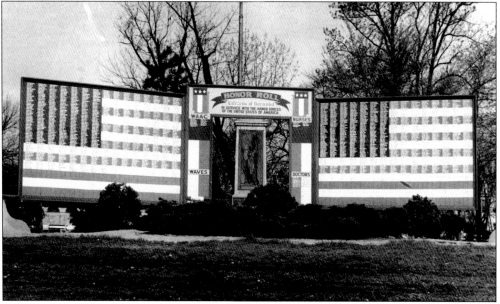

This war memorial is in Victory Park. The center monument is dedicated to World War I veterans, and the list of names surrounding the structure is the Norwood Honor Roll of World War II. The honor roll lists the names of more than 2,000 veterans from Norwood who served in both world wars.

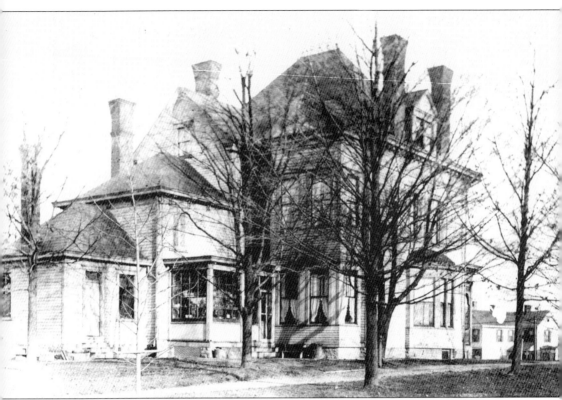

This picture shows Edward and Henrietta Mills's house, in which the couple lived until their deaths. Edward Mills was born in Norwood on November 28, 1837, when the area was still called Sharpsburg. Edward's parents were Stephen Mills and Sarah Smith Mills, and his grandfather Abner Mills originally settled in Columbus Township in 1789. Edward married Henrietta Flinn in 1869, the same year he built a house for them to live in on 4311 Main Avenue, as shown by this picture. Edward was a trustee for the Norwood Public School District from 1870 to 1884 and was one of six members elected to the first Norwood council after incorporation. He also donated land for Norwood's public library at the corner of Wesley Pike and Montgomery Road. Edward and Henrietta had three children; George E. Mills, Alice Cadwallader, and Clara Reynolds. George was the first mayor of Norwood and later became a Hamilton County judge.

This brochure highlights the lodge dedication. The lodge was first chartered as the Norwood Lodge No. 576 on October 24, 1895. The first Norwood Masonic Temple was built on Weyer Avenue in 1913. This building was built in 1927 in the neoclassical architectural style. The facade is similar to the Greek Doric order.

DEDICATION

...OF...

NORWOOD LODGE, NO. 576,

F. & A. M.,

...AND...

INSTALLATION OF OFFICERS,

Wednesday Evening, December 11, 1895,

8 O'CLOCK.

NORWOOD, OHIO.

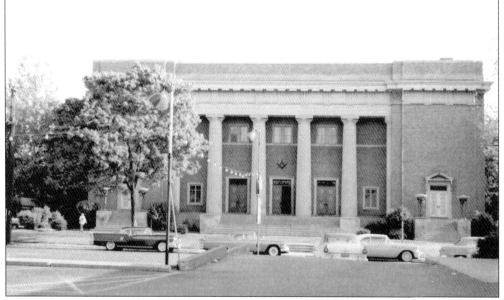

The Norwood Masonic Temple sits at 2020 Hopkins Avenue. On February 22, 1952, the lodge celebrated its 25th anniversary. During this celebration, William M. Judd, the grand master of the Grand Lodge Free and Accepted Masons of Ohio, spoke; Bert Little played the organ; and Walter N. Lindsay presented Norwood's history of Masonry. The original members included Henry Feldman, William E. Gleason, Ethel C. Bolsinger, Hattie C. Miller, Robert R. Kahle, Oliver G. Bailey, and David J. Parry.

This is the house where Vera Ellen lived during her years in Norwood. Ellen was a Norwood High School graduate and performed with the Norwood High School Minstrels. Ellen was known for her talented dancing moves. She paired with Fred Astaire for two films and appeared in Danny Kaye films. Another famous Norwoodite is George Chakiris, born 1934, who was known for his part in *West Side Story*. He lived on 1925 Sherman Avenue.

These two swords were found near the area at Victory Parkway and Sherman Avenues. There used to be a water hole near this intersection that was often used by travelers passing through. Four horsemen were attacked and murdered at this water hole in 1793 by American Indians. In 2006, the area still goes by the nickname "Bloody Run."

This Lloyd family picture was taken when John was only four years old. He is on the far left of the picture, with his mother, Sophia Webster Lloyd, and his brother Nelson Ashley. John was born on April 19, 1849, in West Bloomfield, New York. The family moved to Burlington, Kentucky, in 1853 so John's father, Nelson Marvin, could work as a railroad surveyor.

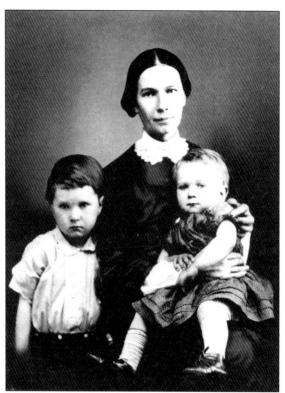

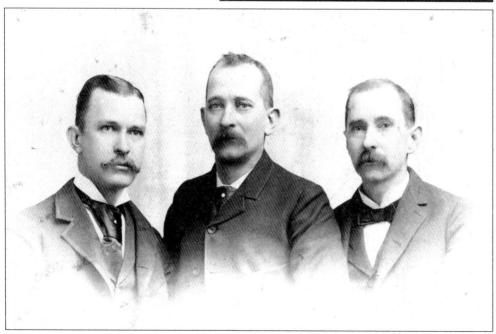

This old photograph shows the Lloyd brothers, from left to right, Curtis Gates, John Uri, and Nelson Ashley. Nelson was born two years after John, and Curtis was born on July 17, 1859. The family also adopted a baby girl named Emma. A baby boy, Robert Llewellyn, died at three years old.

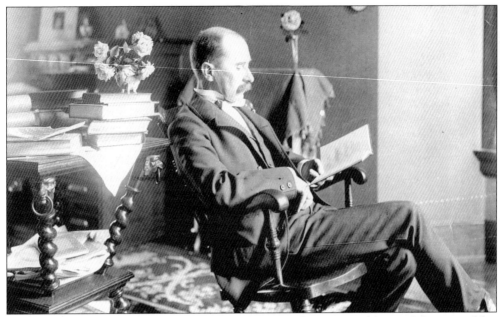

This picture of John Uri Lloyd shows him relaxing in his Norwood home. John started his apprenticeship at W. J. M. Gordon and Brother shop and next studied under German pharmacist George Eger. He later got his brother Ashley a job at Gordon's, before John started at H. M. Merrell's pharmacy shop. It was at Merrell's that John became interested in the eclectic group of chemists.

This is a picture of John's daughter Dorothy. This picture is thought to be the first taken by John's second wife, Emma Rouse. John first married Adeline Meader on December 27, 1876. However, during their honeymoon, Meader died of peritonitis. John married Emma on June 10, 1880, in Crittenden, Kentucky. The couple had three children: John Thomas on April 30, 1884; Anna on November 18, 1886; and Dorothy on October 28, 1894.

John Uri Lloyd (far left) stands with fellow pharmacists Lewis C. Wiehl and Joseph P. Remington (left to right, respectively). This picture was taken in 1916 at an Association of Pharmacy meeting in Indianapolis. In 1881, John's brother Ashley joined the Merrell firm, and the name changed to Thorp and Lloyd Brothers. John went on to win the Ebert Prize three times, in 1882, 1891, and 1916.

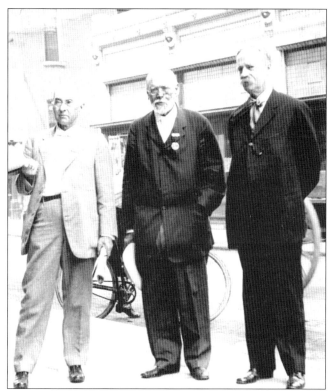

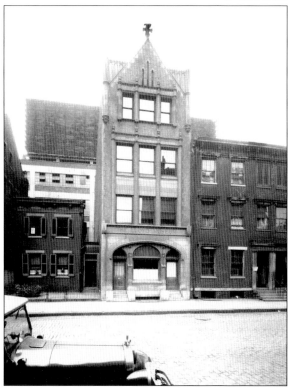

This early picture shows the John Uri Lloyd Museum at 224 West Court Street. John's own collection helped start the library—while conducting research at Merrell's store, John collected books dealing with botany and pharmacy. John died of pneumonia on April 9, 1936, while visiting his daughter Annie in California. In 2006, the museum stands at 917 Plum Street.

Across America, People are Discovering Something Wonderful. Their Heritage.

Arcadia Publishing is the leading local history publisher in the United States. With more than 3,000 titles in print and hundreds of new titles released every year, Arcadia has extensive specialized experience chronicling the history of communities and celebrating America's hidden stories, bringing to life the people, places, and events from the past. To discover the history of other communities across the nation, please visit:

www.arcadiapublishing.com

Customized search tools allow you to find regional history books about the town where you grew up, the cities where your friends and family live, the town where your parents met, or even that retirement spot you've been dreaming about.